MAKING HOME IN HAVANA

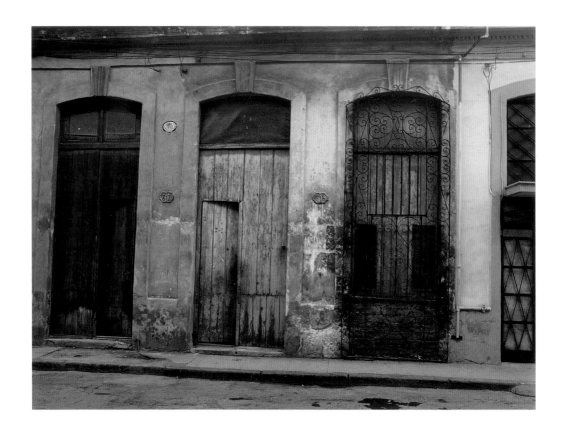

MAKING HOME IN Havana

PHOTOGRAPHS BY
Vincenzo Pietropaolo

TEXT BY
Cecelia Lawless

RUTGERS UNIVERSITY PRESS
NEW BRUNSWICK, NEW JERSEY, AND LONDON

For Emile and Adèle,

and all those who have

given me a sense of home

CECELIA LAWLESS

For Adriana, Emily, and Cristina

VINCENZO PIETROPAOLO

Library of Congress Cataloguing-in-Publication Data
Pietropaolo, Vincenzo.
 Making home in Havana / photographs by Vincenzo Pietropaolo ;
 text by Cecelia B. Lawless.
 p. cm.
 ISBN 0–8135–3094–6 (alk. paper)
 1. Havana (Cuba)—Pictorial works. 2. Dwellings—Cuba—Havana
 —Pictorial works. 3. Architecture, Domestic—Cuba—Havana—
 Pictorial works. 4. Havana (Cuba)—Description and travel. I. Law-
 less, Cecelia Elisabeth Burke, 1961– II. Title.
 F1799.H343 P54 2002
 972.91'24—dc21 2001058680

British Cataloging-in-Publication information is available from the
British Library.

Based on an idea by Cecelia Lawless

Frontispiece: Doorways, San Francisco between Valle and Zanja.

Design concept, editing, and sequencing by Cecelia Lawless and
Vincenzo Pietropaolo.

Text design and composition by Jenny Dossin.
Manufactured by University of Toronto Press, Inc., Toronto, Canada.

CONTENTS

PREFACE

A photographic image. A letter. A conversation. Then, a meeting of minds that evolved into a trip to Havana. What makes a house a home? These were the initial steps and question that formed the foundation of our shared trajectory for this book. Havana is a city that captivates at the first embrace of the Malecón, the seaside boulevard that curves seductively around the city and the ocean simultaneously. We wished to capture through words and images this sense of edge that casts a shadow over the notion of "home" in Havana. A home embraces the concept of community conveyed by family, religion, pets, domestic tasks, and upkeep. But when your house is in ruins how can it still maintain the feeling of home? Through image and word this book has been a collaborative effort between ourselves and the Cuban people whom we came to know and respect. In the end, the project turned into a homing device for all.

.　　.　　.

Van lejos pero siempre vuelven. They fly far away but they always come back.

Juan spoke adoringly of the pigeons that he was raising and that lived in the coop that he had built, crudely but ingeniously, of discarded materials. Shaped like a miniature high-rise building, with individual apartments, the coop had been bolted to the edge of a rooftop wall of his own apartment house in Havana's Vedado district. From a distance it seemed rather precarious, and gave the impression of being suspended or hanging in midair.

The modest structure reminded us of the physical decay and fragility that we had witnessed as we visited many dwellings for the preparation of this book. We watched with utter fascination as pigeon after pigeon, with names like Carmelita or Azucena, flew back to the landing pad near the coop, and then settled inside their respective compartments, or home. The trained birds had been circling in the hot summer sky, attempting to lure someone else's pigeons to their coop. Juan would then try to snare the unwitting visitors, with the intention of later selling them, hoping to substantially increase his income. He explained that this was an accepted and respected practice among his community of urban pigeon breeders in Havana.

As Juan recounted tales of prowess, adventure, and the love habits of his pigeons, we began to understand how his story epitomized the attempts of many Habaneros to step out of the far-reaching but inadequate "cradle-to-grave" system of social care, one of the pillars of the Cuban revolution. It was through such encounters, wherein the indomitable human spirit would surface time and again in the face of a dismal lack of physical resources and in the context of decaying architectural splendor, that the city of Havana would ultimately capture our hearts more intensely than either of us would have ever thought possible. Ironically, our search and exploration of *casa y hogar,* house and home, would start with Juan's fifteen pairs of pigeons, flying freely but always returning to their place of birth, their sense of home.

.　　.　　.

In the same apartment house, Mimí, a *madrina,* or godmother, of the Santería religion would eventually bless the making of the book in a joyous ceremony in which two dozen guests would share in the layers of

chant and invocation, drumming and dance, rum and cigars, fruit and cake. Central to the ritual was a white dove, held over each person, and slowly passed around over every part of the body, as an act of purification. Quickly, some of the participants' enthusiasm transformed itself into frenzied movements of wild abandon. We both felt privileged to have been invited and welcomed, a rare opportunity for us to partake of the ceremony, and therefore do our work not as observers from the outside, but as participants from within. This is the approach that we tried to follow throughout the project.

Toward the end of our third and final trip, the façade of a small home captivated us through its visibly homemade mosaic and multilayered shades of paint. Margarita and Sergio's home stood out exuberantly on the busy street in Centro Habana, due to the unique use of jagged stone fragments, such as granite, marble, and ceramic tile, that they had salvaged from demolished buildings. Inviting us inside, they shared with us their ideas of house and home, while ironically they were unable to share even a cold glass of water. It was one of the hottest days of the year, but their house had no refrigerator. Small details such as this continually emphasized the drama of the Habaneros' daily quest for dignity and grace. Individual initiative formed the keystone of Sergio and Margarita's *lucha,* or fight, for a sense of place.

We realized then that experiences such as this would mark our own search for home in Havana.

CECELIA LAWLESS
AND
VINCENZO PIETROPAOLO

July 2001

ACKNOWLEDGMENTS

We would like to express our thanks and gratitude to the many people who offered resources, helpful suggestions, or words of encouragement as the book progressed from an idea to published form. The idea for the book could never have seen the light of day without the initial financial support of Cristian Arsac.

In Canada: Giuliana Colalillo, Meeka Walsh, Anna Prior, Maura McIntyre, James Aquila, Liane Regendanz, Denyse Gérin-Lajoie, Simon Balon, Janusz Dukszta, Wolfe Erlichman, John Moffat, and Linda Dixon.

In the United States: Pierre Sassone, Robert Cooper, Debra Castillo, Gerard Aching, Anabel Echevarría, Jeannine Routier-Pucci, Kathy Davis, Paul Cody, and Judy Black.

In Cuba: José Alberto Figueroa, Isabel Cristina Espinosa.

We would also like to thank the following people in Havana—the subject of this book—whose words and images may or may not have been used in the book, but who graciously consented to being photographed, and spoke with us about their ideas of house and home. To all these people, and more, we feel indebted: Giorgio Alberto, Orlando Fernández Alvarez, Iliana Amador, Juana Arestoy, María Bacinto, Susana Angelina Bovey, Sarina Cabrera, Consuelo Castro Chávez, Edy Ciarreta, Reinaldo Clavel, Combinación de La Habana, Anselmo Cuadra, Particio Cuadra, Marisel Cuadra, Liliana Fuente Cuadra, Miguel Martínez de la Cruz, Ana María Rodríguez de Lara, Zaída de Río, Juan Delgado, Nancy Loyola Edreira, Victor Emanuel, Dylon Fernández, Nandy Mosquera Fernández, Elvira Florean, Kevin García, María Pilar García, Margarita Sabuada Gilis, Roberto Martínez Gómez, Dany and Jairo González, Mirta Sánchez González, Hernando Guzmán, José Alberto Hernández, Ismael Chico Hernández, María Tampa Hernández, María Ibane, Fernando Lagorde, Teresita López, Ruth Machín, Díaz Díaz Magalys, Marisa Marqueti, Bárbara Martínez Márquez, Cristina Amorán Martínez, Martha Fernández Martínez, Mercedes Peñalver Martínez, Juan Marduchi Menédez, María Ester Meriño, Alberto Lázaro Montiel Morales, José Ferrer More, Juan Carlos Chirino Oliva, Hijinia Bell Olivare, Francisco Olivera, Miguel Ortega, Juan Pérez, Aida Hernández Pérez, María Ramírez, Jorge Luis Ramírez, Oscar Rawlins, Reuben Reyes, Adela Rodríguez, René Agosta Rodríguez, Angelina Virginia Viña Rodríguez, Irma Rosales, Lázaro Samora, María Esther Sanatana, Walter Gallardo Sazarya, Ignacio Soldonzo, Raul Luquero Suavez, Sergio Tielles, Lázaro González Valdés, Felix Milanés Valdéz, Eduardo Fernández Villaba, Reinaldo González Villaba, Ada Williams, and, of course, la Madrina, Mimí, for spiritual and poetic guidance.

We are especially grateful to Alex Fleites for his Prologue and the use of his poem "Waiting for a Train" and for his unfailing, patient help throughout the creative process.

Finally, we would also like to express particular thanks to Leslie Mitchner, associate director/editor in chief of Rutgers University Press, whose initial faith in the project and continued enthusiasm allowed it to come to fruition.

PROLOGUE

Havana, more than a city, is a state of mind. Aside from being a metropolis, beautiful if tormented, Havana represents a single act of appropriation, a collective invention, a superstition, a wound in the sea, and an object of pride for its inhabitants. These contradictory qualities have defined Havana ever since the Spanish explorer Panfilo de Navárez decided to found it in 1514, facing the Gulf of Mexico, embracing a secure bay, although exposed to the ferocious winds of the Caribbean.

On the one hand, Havana offers streets perfectly traced, splendid mansions decaying into ruins, buildings of a doubtful futuristic vision, parks through which the city breathes. And, on the other hand, there exist the songs, the poems, the novels, the paintings, and the photos that try to place, to secure Havana forever beyond the solidity of stone.

As often occurs, reality ends up imitating art. And the city resembles more and more its reflection, its legend, that which all the inhabitants take from her to incorporate into their own vital baggage. Just as nature became transformed into landscape for us through the work of the nineteenth-century Romantic poets, so the urban complex became a city thanks to the troubadours, the soneros, the photographers, the neighbor's children, all of whom have inscribed on Havana their own romantic subjectivity.

In a few words: Havana is above all its people who erode and construct her, who negate and exalt her, who dwell in her daily.

To be a Habanero does not only signify being born or having lived for a long time in the city. It also represents a philosophy, an affiliation, a certain sensual mode of relating to others in a desperate act to identify with and to understand a singularly peculiar sense of time.

Since the first decades of the nineteenth century, El Vedado, as its name indicates—"the Park Reserve" —was a zone for the "common man." Acting as a reinforcement of an emerging bourgeoisie, majestic palaces went up here looking toward the sea. Eroded but not vanquished by time, they continue to house numerous families who are impacted by the transitory nature of these dwellings, even though the debilitating passage of time began many generations ago.

Home represents an ideal place to experience our sense of intimacy. It is a place where we have our plants and our furniture, paintings and portraits, where we receive our friends. Many Cubans locate the home in an improbable future, which in no way do they wish to renounce. In the meantime, we continue to exercise our right to exist, knocked about by outside forces that have as much to do with an overwhelming and suffocating climate as with the need to "hustle," to "unravel," to "invent" from a neighborhood what we cannot find in the closed frame of the house that supposedly shelters us.

The neighborhood is an institution that fights against the vertiginous rhythm of modernity. Even today, neighborhood intersections in Havana serve as corner "businesses" where you can listen to the latest music, exchange information and favors, make a date, and settle questions of honor. The neighborhood is the skin of the house just as the house is the skin of the family. The individual, the family, the house, the neighborhood, the city are all indivisible, something that the authors of this book can easily confirm. Here, in words and images, appear the heartrending and living testimonials that Cecelia Lawless and Vincenzo

Pietropaolo have gathered from today's Habaneros. The object of their study is the relation of men and women with their homes. The outcome overwhelms them. In my opinion, this book essentially presents that difficult task of living, in general, and of living in Havana, in particular.

During repeated visits, the authors were bolstered by their lucidity and sensitivity as they became saturated with the essence of the Habaneros. Cecelia and Vincenzo have listened to the city's stories and then have returned these enriched with a poetic gaze that restores their complex reality.

Between reality and the truth there is more than one difference. Usually one tends to accept reality as an ensemble of truths. I have no quarrel with such a definition, but I would only wish to add that, in this case, it must surely be a question of essential truths.

One cannot tell a life, much less synthesize it. Nevertheless, one can access its fragments. True and vital fragments of today's Habanero have been captured in these pages. There cannot be better praise or merit for the work of Cecelia and Vincenzo.

ALEX FLEITES

Havana, Cuba
2001

MAKING HOME IN Havana

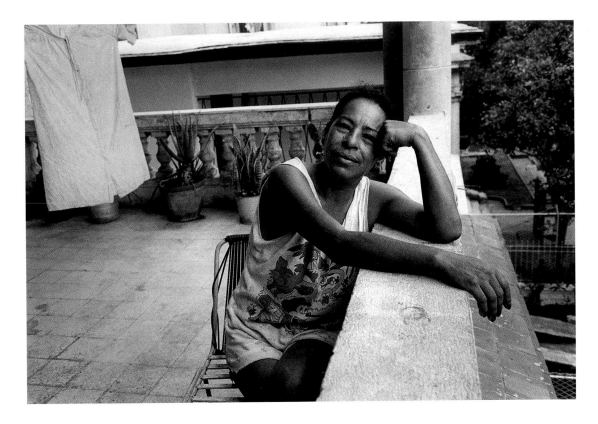

Tell me a story. These are words that speak across cultures. We all want stories to learn about others, to house them in place and time. In story-telling, the narrating word provides the foundation of a home. Photographs tell stories too. Captured in an instant, they resonate for much longer. In this book, the words of Cuban people add a textured voice to the visual and reflect the multilayered construct of home. A story. Although the voices in the texts are not necessarily those of the people in the juxtaposed images, interwoven they form a locus for home. Thus the Cuban people themselves become mouthpieces for the buildings: unmediated, direct, their words with the photos tell a story of places they hold dear.

As the dramatic effects of time and climate erode the architecture in Havana, forcefully arresting its development, there is an urgent need to document, to learn to read the dwelling places that soon will not exist. The city, looking eastward toward the sea, is framed by the embrace of the Malecón—the seawall. Wind and sea spray penetrate the streets and add to the poignant beauty of dilapidated buildings that are the result of historical evolution. Music is the under-current of this city inhabited by people who are proud of their mixed heritage—Spanish, African, Chinese, and North American. Havana is a city that rarely fails to captivate the eye. Traditionally, the ideal of home is associated with stability, but in fact the home locus represents a place of coming and going,

leaving and returning. Today this movement has stultified in Havana, undermining a fluid sense of home in process, because economic and practical concerns—the lack of houses—make moving from one house to another very difficult. This book presents the idea of a "house" as the structural form of a site that exists in real time and space and that is a relatively stable entity. "Home," on the other hand, unlike the traditional idea of a family-oriented, community-based, inherently stable ideal, usually can be, but not always is, contained or enclosed by a house. We view home as a site that can exist in the form of a song, a tree, a person, or a house; but it is a site that is in constant process, involving a coming and a going, a place from which you can leave but to which you can return, changed, to leave again, over and over. "Home," then, is the personal and the more political term that involves the process of identity formation and the details of everyday living.

Day after day, Vincenzo Pietropaolo and I walked the residential streets of El Vedado and Centro Havana with camera and tape recorder. Our work was like an archeological dig as we explored neighborhoods steeped in oral and visual histories. Everywhere people welcomed us into their houses, where we would exchange questions about their ideas regarding house and home—*casa y hogar*. Usually, people would find no differences between these two concepts, but as they continued to answer questions about their houses, tell their stories, narrate their place, differences would become apparent. We began to realize that in the often unpoetic struggle of daily living, some nuances of language become less important, and we had to look for gestures that would reveal a sense of home. Everyone had a house—a structure to cover the head, to keep off the rain—but not everyone felt the need, quoting one of the young Cubans we met, "to participate with the heart to make a home."

Pietropaolo and I were aware of our own cul-

tural, social, and economic distance from the people that we were engaging—not to speak of the geographic separation that encloses a whole set of political differences. Like many Habaneros who had come from the countryside to live in the capital, we too were "dislocated" to a certain degree. We did not want to aesthetisize from this, our removed location, and so we believed that the interweaving of spoken/written language with the photographic image would be a more evocative entryway into what various theorists have called the "everyday practice" of homemaking. Housing can be the social mirror of a city.

Constantly walking at the slow, local pace, we decided to concentrate mostly on one neighborhood, El Vedado, just past Centro Havana, since we wished to explore the disintegration of specifically twentieth-century domestic architecture in Havana. El Vedado was founded in 1859, and its oldest buildings are from the neoclassical style of 1890. But what appealed to us were the more eclectic codes of architectural styles employed in the majority of houses built from 1919 to 1930. Originally a residential neighborhood outside the center, El Vedado forms the modern heart of this polycentric city today as various social institutions anchor this area, such as: the Hospital de Calixto García; Coppelia Park with its world-renowned ice cream parlor; famous hotels like the Palace and Presidente; the Universidad de La Habana; and many *paladares*—small, private restaurants in people's homes. Some buildings are stunning in their recent renovated state, a sign of foreign money, and others are in various states of disrepair. But, unlike Habana Vieja, the lots are larger because zoning laws originally mandated five-meter setbacks from the street to provide more green space, and so the natural setting as well as the people welcomed us here.

Our walks were a delightful exercise in establishing intimacy with the people from the street level. We learned to linger and would stop and ask about a detail of a house—a window's stained glass, a twisted

column in a patio, flowers in a small garden patch. Much of the Habanero's domestic life occurs in the street because of the heat and often-cramped quarters inside. Severe fuel shortages have reduced automobile traffic. This opens up the street for social interaction. Traveling by foot greatly enhanced our opportunities to engage with people who were curious, friendly, and only a little cautious about having contact with people like us from *afuera*—outside.

People in Havana were very willing to talk with us. To establish a rapport quickly with someone is not always an easy task. But when you show respect and interest for their dwelling place and its history you have opened a door to dialogue. These exchanges with Habaneros often led to an invitation inside the house or apartment to show us more. Only a couple of times did people resist our inquiries. They did not wish to show us the "ugliness" of their surroundings— ironic in that this deterioration or decadence rather appealed to our Western sensibilities. This ugliness—peeling paint; cracked walls, sidewalks, roads; crumbling roofs; broken shutters, and so on—is part of a private space not to be revealed because of modesty and pride: they did not want foreigners to receive a bad impression of them and their country. But usually, words and gestures became a way of bridging geographic and other kinds of distance. It is these words and gestures—the oral testimonies and the photographic images—that we wanted to capture for a still moment on a page. While Pietropaolo explored the interiors of houses, I would sit, often with a cup of strong Cuban coffee, and chat with the men and women we met. Many were retired or older or without full-time employment. They wanted our impressions about Havana and had time to answer questions as well as to express their curiosity about us. A recurring theme was the difficulty they had in obtaining materials for house repairs, which they often blamed on the U.S. embargo, imposed in 1961. All spoke with affection for their houses, where many had lived for decades.

These inhabitants were as diverse as the houses where they lived. We talked with Margarita, a mother of two, whose teenage son dances with the National Ballet and whose house is spacious and glows with the afternoon light. José and Muriela, a retired couple, live in one of El Vedado's few wooden dwellings, reminiscent of a New Orleans shotgun house. Their home has exhausted them with its upkeep, and they list many complaints. Raul works with senior citizens and prominently wears Santería beads, indicating an Afro-Cuban religion once prohibited by the government, but now fully accepted and practiced by many. He is an active man in his sixties and has added a room in his patio for his son's growing children. Cristina lives in a refurbished *cuartería*—a dilapidated rooming house in a former mansion—where she has done all the renovation herself. She has four children in her one bedroom, but is full of pride in what she has accomplished as a decorator, mother, and teacher. Another older couple, Rodrigo and Selma, live in two rooms in a once elegant apartment building. They built a *barbacoa*—sleeping loft—for their five children, now grown, and they have worked hard to make an intimate space in a room without windows. Anselmo lives in a rooftop room of an old house and grows basil in pots outside his door. Ruth and her husband have a large and beautifully renovated house financed by her daughter in Venezuela. All these people and many more opened their homes and lives to us. Slowly, we came to know them, and we visited with them day after day.

The city of Havana is a work in progress, like most cities, constantly evolving and reconstructing itself, its houses and other buildings deteriorating while new structures or vacant lots take their place. Since there are few modern, tall buildings a respatialization has occurred, a new horizontality that in a sense levels out place for everyone. Tropical storms also take their toll on the buildings that become

flooded because the Malecón, the seawall promenade, is not adequate for the wind and high waves it receives. Emblematic of the Caribbean, Havana represents an amalgam of disparate and heterogeneous parts, the plural traditions of different peoples and groups whose complex and shifting interactions make up the actual shape of what is then imagined as a home.

· · ·

As an island, Cuba has had a history of movement. People come and go. The city was founded in 1519 by Diego Velázquez as "la villa de San Cristóbal de la Habana." A port city, it was a *llave del mundo*, a "key to the world" with a chessboard layout typical of the times, mandated by the Law of the Indies (1573). Running north-south were the institutions; in the east-west direction were commercial enterprises and artisans. Through the centuries, Cuba's housing situation has reflected its general level of development and its history of dependence on foreign powers, first as a Spanish colony, and from 1898 until 1959, as a neo-colony of the United States. The country's enormous sugar earnings and its role as the center of Spain's declining empire meant that Cuba urbanized earlier and accumulated relatively greater wealth than most other Latin American nations. Much of this wealth was channeled into public and private building in urban areas.

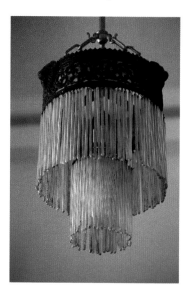

The city wall, which contained the city's growth, came down in the 1830s, and the urban area tripled, but the population only doubled, producing an outward east-west movement. Havana spread into the mode of residential and highly decorative dwellings. After the War of Independence with Spain (1898), the emigrating bourgeoisie abandoned old houses and decay set in, with the division of larger homes into multifamily dwellings known as *cuarterías*. This marks the beginning of a century-long cycle of decay of Havana's dwellings. The world economic crisis of the early twentieth century led to a decline in the price of sugar. This, in turn, led to a large exodus in Cuba from the countryside to the capital. The old city became denser both in its population and in the layering effect of its buildings. Makeshift rooms were built on roofs and in courtyards; houses were divided into smaller and smaller living quarters. Residences in El Vedado, a middle-class neighborhood influenced architecturally by Catalan modernists and a large English population, began to deteriorate as well.

During the reign of Batista (1933–1958), many modern buildings were erected between El Vedado and El Centro without much thought or planning. A growing interest in land speculation meant that small dwellings were sacrificed for large apartment complexes. In particular, 1953–1958 saw a construction boom of the modernist style. Twenty percent of the Cuban population lived in the capital. In 1953, more than four-fifths of the rural dwellings known as *bohíos* consisted of thatched-roofed huts with dirt floors, and fewer than 10 percent of rural houses had electricity or plumbing. In contrast, the vast majority of urban dwellings had electricity (95 percent in Havana). But half of Havana housing was considered substandard, without complete sanitary facilities and with an evolving squatter scenario in its *cuarterías* and *ciudadelas*—tenement houses built around an interior courtyard, reminiscent of, for example, Spanish dwellings in the Middle

Ages. One hundred families could live in a *ciudadela* and twenty to thirty in the smaller *solares*. Even though this period of Cuban history saw a great influx of money, the housing situation reflected only one small sector of society who benefited, and the proliferation of such inadequate dwellings reflects a social change whose impact modified the inner city and even to some extent that of El Vedado.

Cuba's housing policy was neglected for the thirty years following the Revolution in 1959, particularly in the urban sectors. Instead, the government concentrated on the rural areas and their socioeconomic problems, universal medical care, and free education. By 1982, however, UNESCO had recognized Habana Vieja as an architectural jewel and declared the city a World Heritage Site. This designation motivated and funded the rehabilitation and restoration of Havana's colonial center. Thirty to 50 percent of these buildings were still considered very much deteriorated at this time.

Neighborhoods such as El Vedado, however, have been left to their own devices. Only through private money, almost always from abroad, can they rehabilitate built structures. People constantly complain that the condition of their houses grows increasingly intolerable. Inadvertently, or perhaps ironically, the Revolution has assured that Havana's Colonial, Art Deco, and Art Nouveau architecture has been preserved. Virtually no modern construction has occurred since 1959. There are no peripheral satellite cities of the very poor as in other Latin American countries; there is also no eviction without a guarantee of resettlement. Since 1939, through the Revolution period, rent control has existed in some form. However, there is severe overcrowding and little maintenance. Construction since the Revolution has become expensive and has not been viewed as an explicitly productive investment.

The 1960 Urban Reform Law banned private housing for profit and instigated housing as a free public service rather than a commodity—an important socialist difference in conceiving of home as opposed to the attitude of capitalist countries. Early measures included halting evictions, reducing rents, ending land speculation, and initiating self-help and government construction of housing. The infamous *cuarterías*—buildings where families living in one or two small rooms, sharing common sanitary facilities—became government property with no compensation for landlords. All mortgage agreements were canceled for former landlords and homeowners. At this stage, no large-scale redistribution of housing occurred. Small families living in mansions remained in place, as did large families living in only one room. The majority of tenants became homeowners, and people were able to own only one permanent home and a vacation house. But scant material and human resources were devoted to maintenance and repair, leading to severe deterioration.

Until the late 1970s the only way to move involved trading your house for another through local Housing Exchange Offices. But there does exist an informal exchange called *la permuta*—swapping, in a more or less underground, word-of-mouth transaction that was legalized only in 1992. Obviously, distribution of vacant housing did occur between 1961 and 1962, when tens of thousands of people left Cuba for the States and elsewhere. The government distributed 20,000 vacant units to people associated with local unions, to families in *cuarterías* or displaced by fires, to veterans of the revolutionary war and other high-priority sectors. By 1972, 75 percent of all householders owned their homes, 10 percent paying amortization payments, 8 percent paying rent, and 6 percent living rent-free in government-owned buildings. As a billboard on the road to the airport proudly announces, "200 millones de ninos en el mundo duermen en las calles—ningunes cubano." (Two hundred million children in the world today sleep in the streets—not one of them is Cuban.)

As Cuba's housing and overall development policy evolved over the next two decades, new measures were instituted to respond to changing realities. This process culminated in the comprehensive 1984 Ley General de la Vivienda—General Housing Reform—that among other policies promotes home ownership and greater resident participation in building and maintaining structures, and permits limited short-term private rentals. Housing is considered a form of personal property, not a means of production. Housing represents a basic level of necessity accessible to all, similar to food and clothing, which are rationed and subsidized. Neighborhoods have become socially and racially integrated. This is evident in El Vedado, for example, where *ciudadelas* filled with people of all colors occupy the same street as a large single-family house still intact, with people of the same race. Supposedly, housing is constructed to meet social needs, not for profit. However, where renovation occurs, in areas such as El Vedado, private investment is visible and is becoming more frequent.

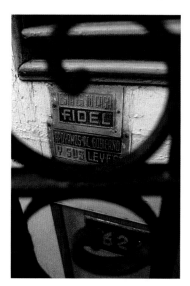

Since the fall of the Berlin Wall in 1989, Cuba has experienced an acute lack of hard currency. Beginning in 1992 the former Soviet Union no longer economically subsidized the island. Castro euphemistically calls this the *"periodo especial"*—"special period." Buildings are in such a state of disrepair since the "special period" that there no longer exist taboos about how to use them. Former mansions house numerous families with no illusions of privacy. Many Habaneros we met spoke this recurring phrase—"Este es mío" ("This is mine"). They refer to a small windowless room with barely enough space for a bed, or to a patch of ground where a few flowers grow. Cleanliness and care define these spaces, and a muffled sense of ownership and

pride. Although there is no homelessness in Havana technically, conditions can be difficult: people live on the edge.

. . .

The photographs here present images of various activities associated with the home—drying laundry, working on a car, feeding a baby, playing on trees, ironing, resting, dreaming, praying. The religion Santería is also a form of home constantly evident in the brightly colored beads that people wear representing different gods. Omnipresent are offerings comprised of strips of colored fabric, seashells, or pieces of chicken in cemeteries, outside the railroad station, and on the sea wall. Because in Cuba there is a relatively finite means of material expression for most people, they cannot express themselves through consumer goods. We cannot only read the things that are store-bought, and hence carry supposed social legitimacy, prestige, and power; instead, the very things and gestures produced within the home become charged with meaning—the cup of offered coffee, the chipped glass of juice.

I recall sitting in a plastic garden chair in a room in the house of an elderly couple. Our hostess insisted upon offering me a glass of fresh mango juice. I refused because I really was not thirsty. The woman was adamant. At this point her son interjected, looking at me straight in the eyes, defiantly asking: "So you do not dare to drink our mango juice my mother just prepared this morning?" In fact, I had vowed to try to avoid Havana tap water at all costs, but taking the cue I smiled graciously and accepted the glass of juice, from a fruit that I do very much like. The man-

gos had come from the father's sister's garden outside Havana and were considered a real treat. After this gesture, conversation flowed much more easily between us, and Pietropaolo managed to take a revealing close-up of the corner kitchen hanging with pots and pans, covered with many tiny cockroaches.

On another day, while climbing up a crumbling rooftop staircase, we could almost taste the seductive smell of fried garlic. The old man Anselmo opened his kitchen door and welcomed us back to his house with open arms. We had visited with him on our previous trip. As he continued to prepare lunch, his three grandchildren came tumbling into the two-room dwelling, very excited at our presence. Many photos of lunch-making and children playing were taken. As we left, the girl reached up to the wall where there hung a small wooden plaque—"Que Dios bendiga mi hogar"—"May God bless this house"—next to the Pope's picture. "Take this," she said, "since you are doing work on houses and their meaning." Now the walls would be bare except for the Pope.

Two elements consistently appeared in our observation of Havana houses large or small: the lack of privacy and the lack of movement. Because of heat and cramped quarters, the allure of the street, people are visible all the time. What is the history and development of privacy in a Caribbean setting and in a post-revolutionary setting? Is it essential for a sense of community? For example, in a *gemela*—a semi-detached house—live two women, both artists, strong women who share the house divided by a wall. Zaída, dark-haired, puts mascara on while holding a mirror to her face as she talks to us: an intimate gesture shared with strangers who have come to inquire about the paintings we glimpsed from the street. With the door open, she concentrates on her face, shaping her eyes. In the other house, María Helena greets us with a metal bowl in her hands. Her house is also filled with paintings. After giving us a brief history of the building, she sits down and proceeds to have a foot-

bath administered by a friend. In another street encounter, two men in an apartment gesture to us to come into their rooms when they see us staring up at their lovely wrought-iron balcony. One is very thin; the other has a firm but rounded belly. The thin one has no shirt on and so we see his prominent collarbone and sculpted rib cage, and the other greets us in gaily colored swimming trunks. Both of them appear completely oblivious about being half-naked in front of us. Because of the density of the city, there are few places where one can be alone, inside or outside a house/home. These instances of a different comfort level from a North American perspective are also typical of tropical living.

Mobility is often associated with modern progress, and yet the idea of being grounded in one place is now a highly valued condition in North America. In Havana, people live in one place for decades. Often, I asked people how long they had lived in their houses. Repeatedly, they would invoke the same numbers—"Treinta y dos años." "Cuarenta." "Cuarenta y tres." ("Thirty-two years." "Forty." "Forty-three.") Is it essential to associate long-term living in one place with a sense of home, or has this become an idealization of a sense of home for Americans? The architect Lebbeus Woods stated after his visit to Cuba, "We are all travelers today, strangers away from home, from any place of origin. Home is today a concept of movement, and origin is only in the mind."

Even words or images seem inadequate to communicate the movement of life in Havana. Streetscapes form an eloquent statement of how people occupy, create a private space, a home. In Habana Vieja, Centro Habana, El Vedado we felt the flow of people, distinct smells of garbage, leaking gas, gasoline fumes, sewage, sweat, and cheap perfume. Sometimes food cooking. Now and then the sharp acrid smell of Hueso de Tigre—"tiger bone" rum. All these sensations culminate in the Malecón, the living room of the city.

People escape from their cramped lives to this open seawall promenade that curves round Habana Vieja to Miramar just past El Vedado. Although a modern encircling of the city was constructed only in the 1930s, the Malecón defines Havana visually and psychologically. Originally, Habaneros disliked building around the water's edge; that stemmed from Cuba being surrounded by enemy waters. Today the water represents a paradoxical escape from extreme conditions in the city as well as a potential escape to other conditions across the water. Young couples wander here, children play and swim, and tourists take relief in the tangy salt air. Yet, everywhere I look I see garbage: plastic bags floating in the water between the Malecón and the rocks, aluminum cans, paper, actual bags of garbage. This place is even used as a public toilet. Speaking to a young engineer, I wonder if he sees the same water, rocks, garbage that I do, and I ask him if the water is really clean enough for swimming. He responds automatically, enthusiastically "Sí sí, muy limpia; el agua está muy limpia." ("Yes, yes, very clean; the water's very clean.")

Of course our project is not a scientific study of home, but in the neighborhoods of El Vedado and Centro Havana we came in and out of many houses and spent some time with a variety of people. In every home appear the ever-constant photos of the revolutionary trinity—Castro, Che Guevara, and Cienfuegos. Roberto, for example, a tall black man whose teeth look punched in, poses under a Cienfuegos photo that has an eerie resemblance to a picture of Christ. Roberto has a big smile even if it's empty. He is at home with Cienfuegos, one of the symbols of "el triunfo de la revolución," and one of the figures converted into an icon of home. Wherever photos of these revolutionary leaders appear people feel that they will be taken care of. Images of the Sacred Heart of Jesus are the only other adornments found on walls. Perhaps all these pictorial motifs represent the site of solid home foundations?

Or do we make a leap from the photos, from the streets, to the cemetery, not a metaphor, but a home reality—the final resting-place? The cemetery of Cristobal Colón borders the eastern edge of El Vedado. The place is huge, full of large mausoleums and cracked tombstones, sculpted angels graying at their edges. Exhumations are common here because, like the rest of the city, the cemetery is overcrowded. In a transfer of bones from one place to another we watch black hands shake rotted shirts and pants for white bones. The family stands at a distance with handkerchiefs covering their faces, eyes watering with tears. They must provide the old sheets in which to wrap the fragmented skeletons. A cemetery worker we have met, Pura Oliva—a name carried over from slave days—tells us that people come from Miami in search of relatives' skulls. After two years, if a family does not pay the ten-peso maintenance fee, the body's remains will be moved to a *colectivo*—a collective grave—where earth, and bones, and shattered wooden coffins intermingle. In a parallel to this scene, in one of El Vedado's more beautiful houses covered with a deadly nightshade vine, Ruth said to us, "Esta casa es la tumba de mi nieto, así lo siento yo. Aquí yo vivo en él." ("This house is my grandson's tomb; that's the way I feel it. Here I live through him.")

Right now there are no clear answers to the questions proposed here, but we are waiting with eyes and ears open. Perhaps some of the answers are evoked in waiting. The idea of home may be just that—an idea, unattainable for Cubans or for anyone else. In that sense, our book may be an approximation, an attempted trajectory toward home—the text as the locus for home. The final solution of experiencing or understanding home for Cubans ultimately is difficult because of the accumulation of cultural and political sedimentation. Housing problems do not disappear under socialism; they just are handled differently than in a capitalist system. Regardless of government orientation, though, people need a testament from the

past that can help them to find their own role in history, a visual landmark that will orient them in space—all this in a territory that they can identify as their own. How do you make a house a home?

What do you like to do best in your house? I ask Ruth. "Mantenerla. Porque así mantengo viva la memoria de mi nieto." ("Maintaining it. Because thus I maintain alive the memory of my grandson.")

Through the photographs and interviews of Habaneros we wish to evoke and question the meaning of place, which represents a story in constant process. How in the early twenty-first century do we communicate such a concept on an island isolated by ideology and geography so as to create a visual discourse about the shifting foundations of home? Whose home is represented? And what is home when it is in an actual state of deterioration, on the metaphorical edge of ruin? Can images, words strung together through interviews, be enough to capture the ephemeral sense of the home place at the beginning of a new century, the beginning of an epoch, perhaps the beginning of a new political phase?

CECELIA LAWLESS

Ithaca, New York
2001

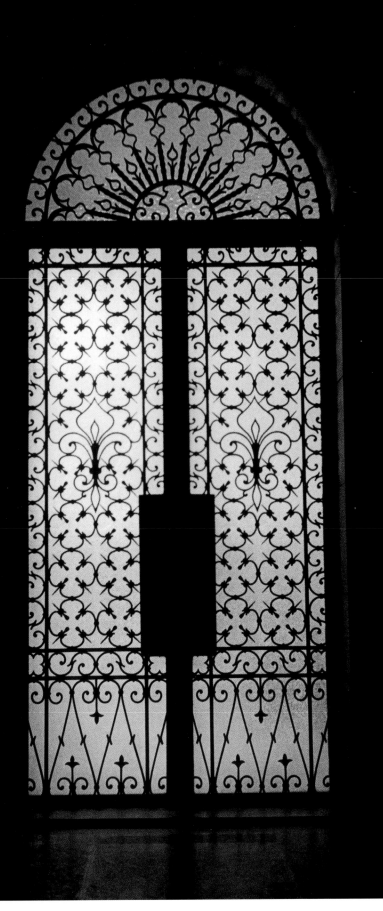

The house, the home, is where our strength is sheltered, that which we cultivate, that which we love, which we want to last. The home represents the realization of people's inner desires. The home is where those desires are born. All the little things, all the thoughts, all the feelings—the home is where they are realized. Where everything starts, where everything becomes harmonized. If the home is not beautiful it doesn't matter, because it's the home that is the base for everything, for everything.

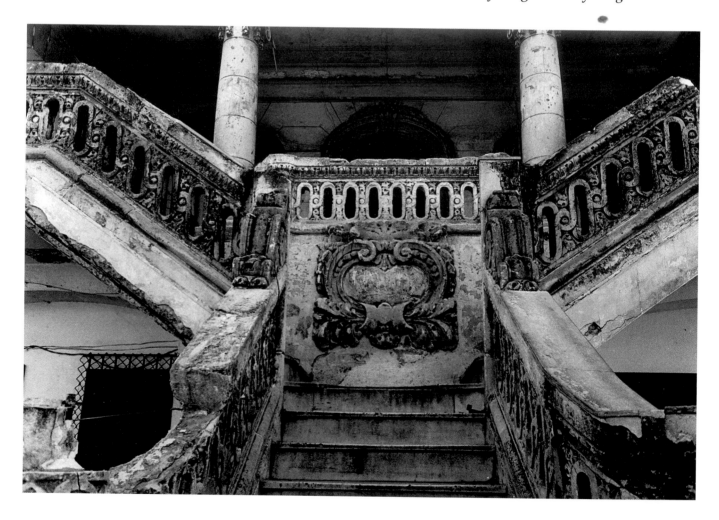

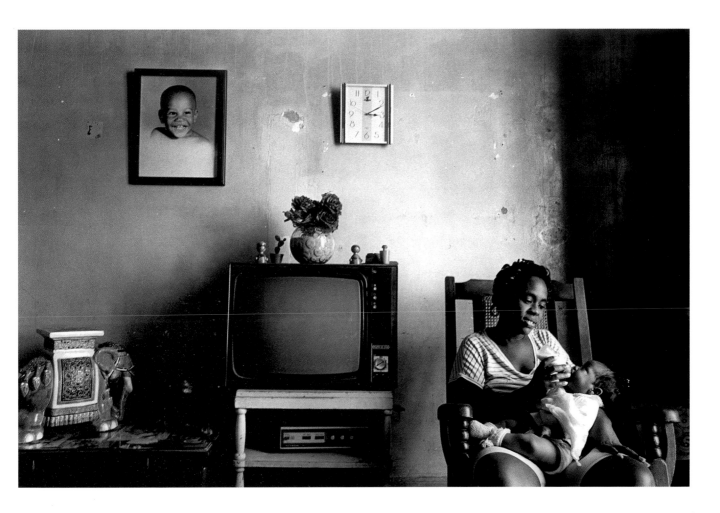

You create a house through a family. It's very important to get along well. The idea of a community is like raising your children.

Here there are children who breastfeed until they're two years old, but mine did for only four months. After that I began to give him normal milk, which is evaporated milk, and other soft foods. But soon he became sick. He began to lose weight and for a week he had diarrhea. So the pediatrician put him on a diet of evaporated milk and, well, that milk made him feel a lot better.

Being a good mother and having a clean and pleasant house is all part of the same job.

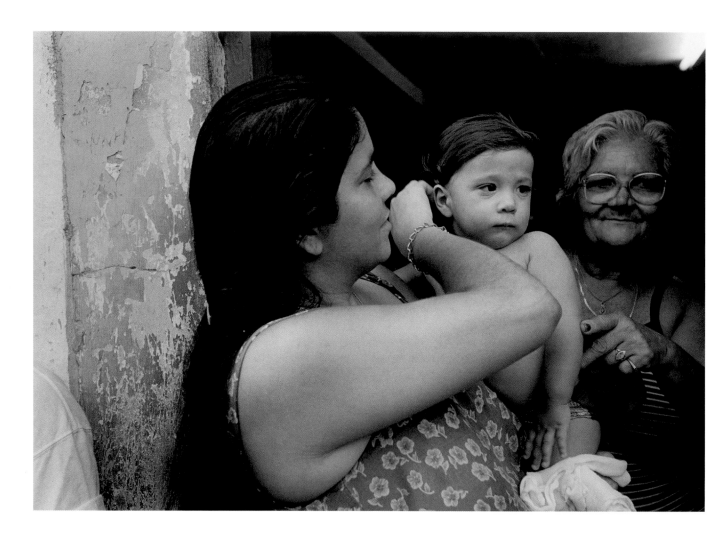

Here in Havana, the daily rhythm is to get up early, like around 6 a.m. I get the children dressed, I comb them, give them breakfast so that they're ready for school. After they go to school, I begin my chores. For example, I have an eleven-month-old baby, so I have to give him his milk and make him his lunch. I'm with him all afternoon.

It's all the same thing. The most important thing in the house, what makes me most happy, are my children. I adore them with my all my soul.

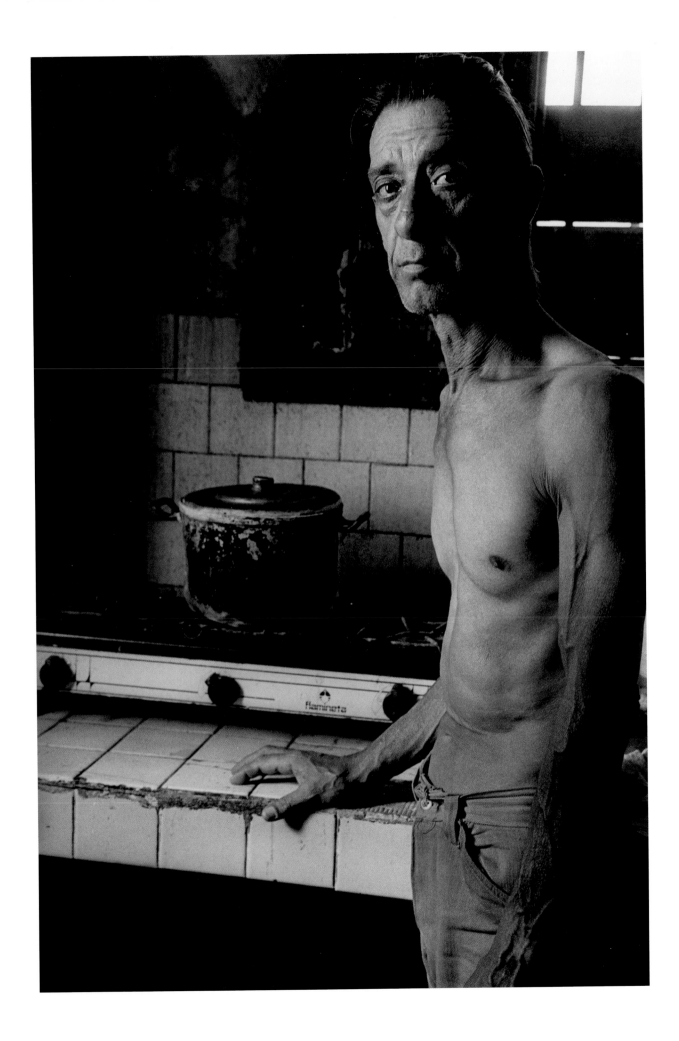

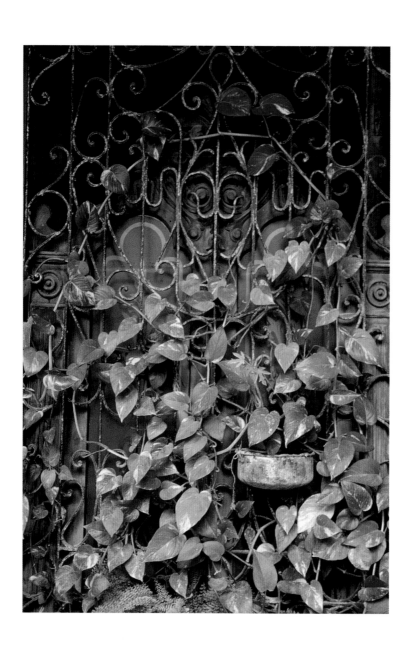

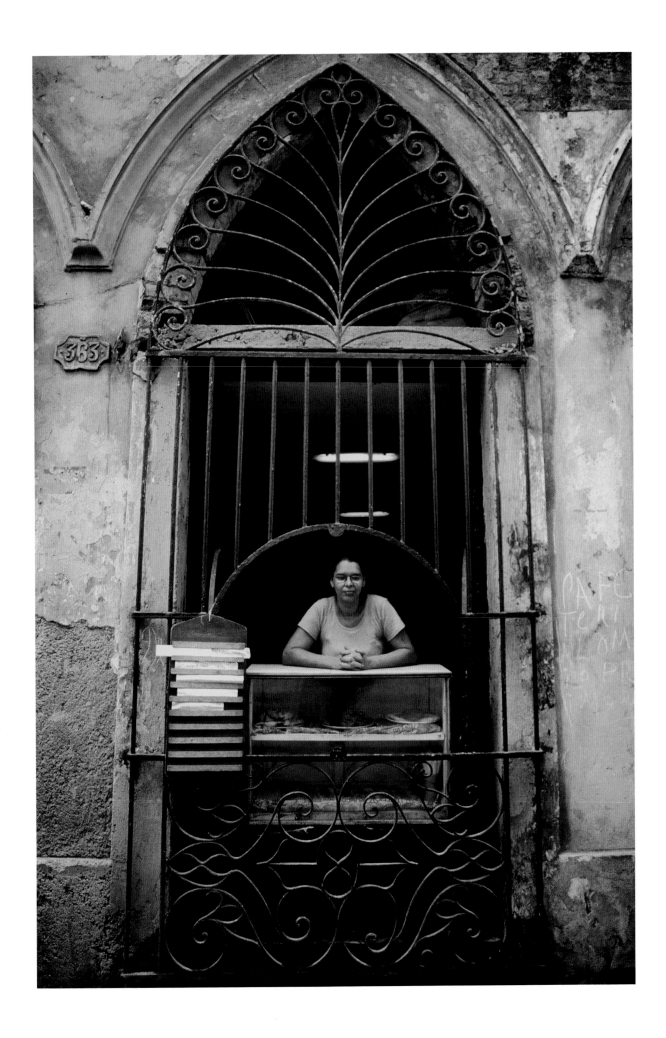

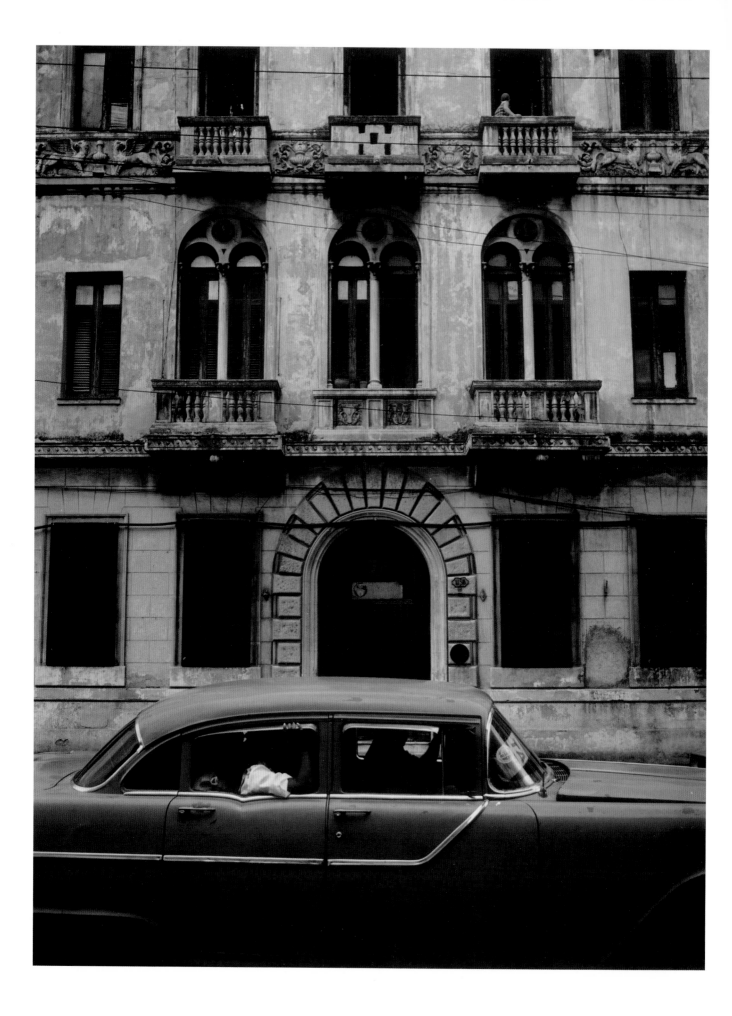

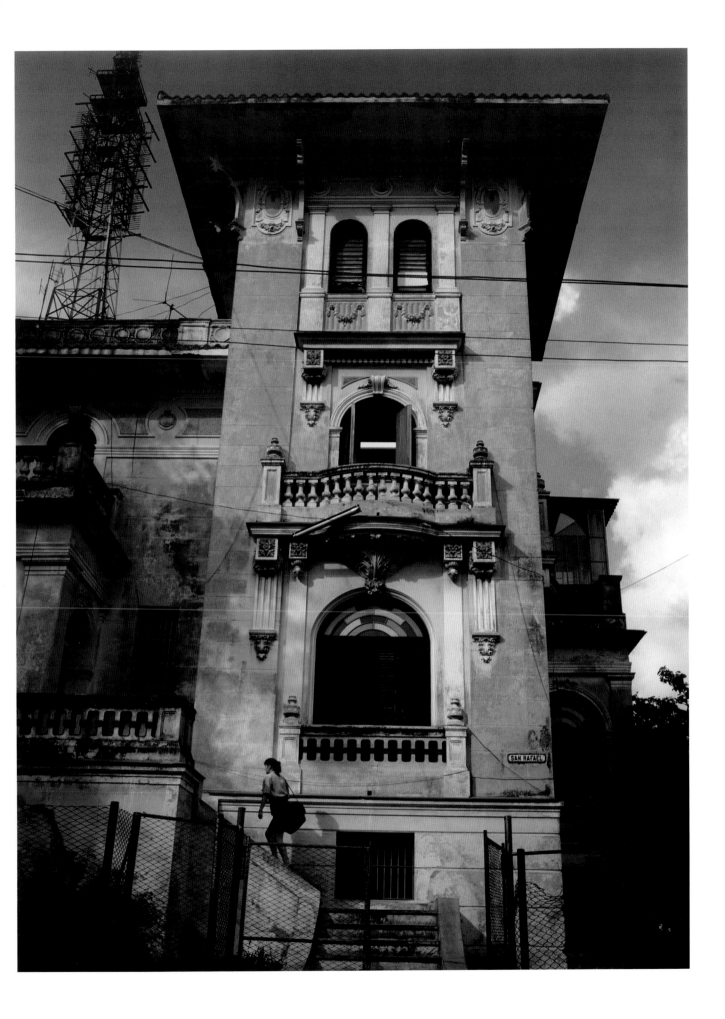

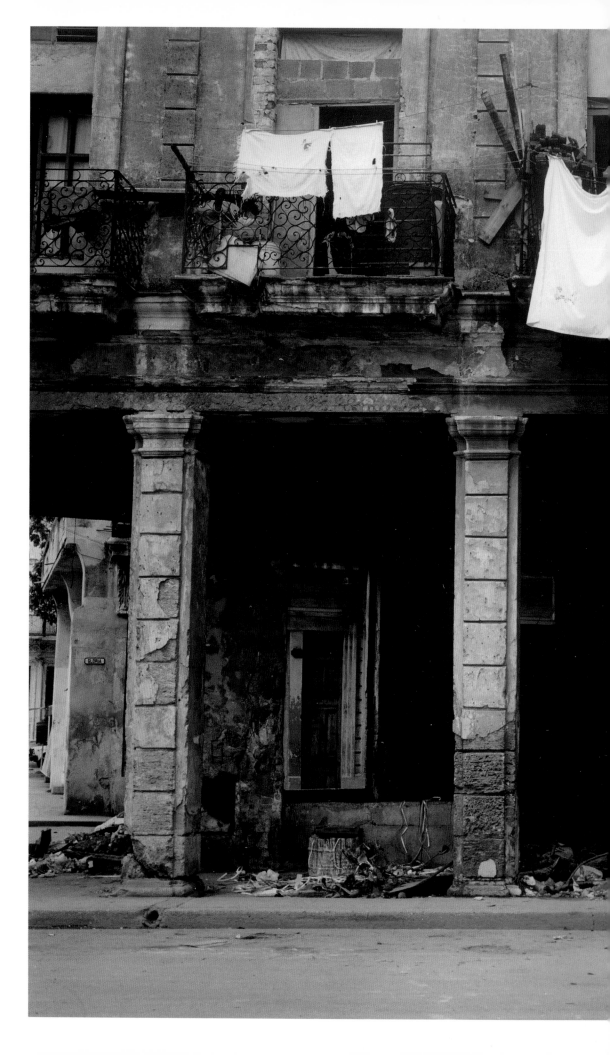

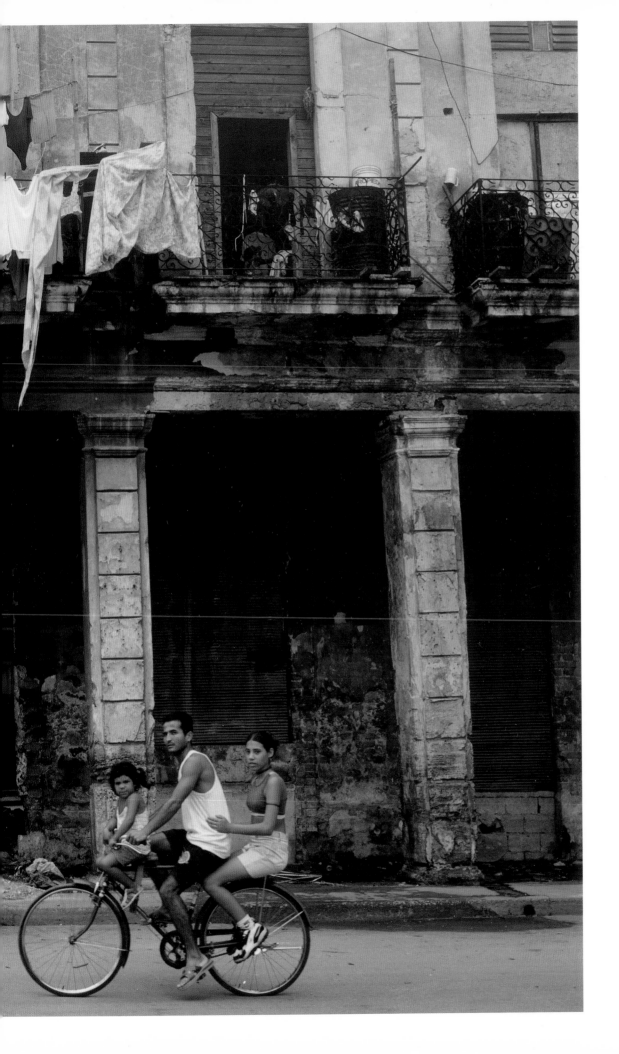

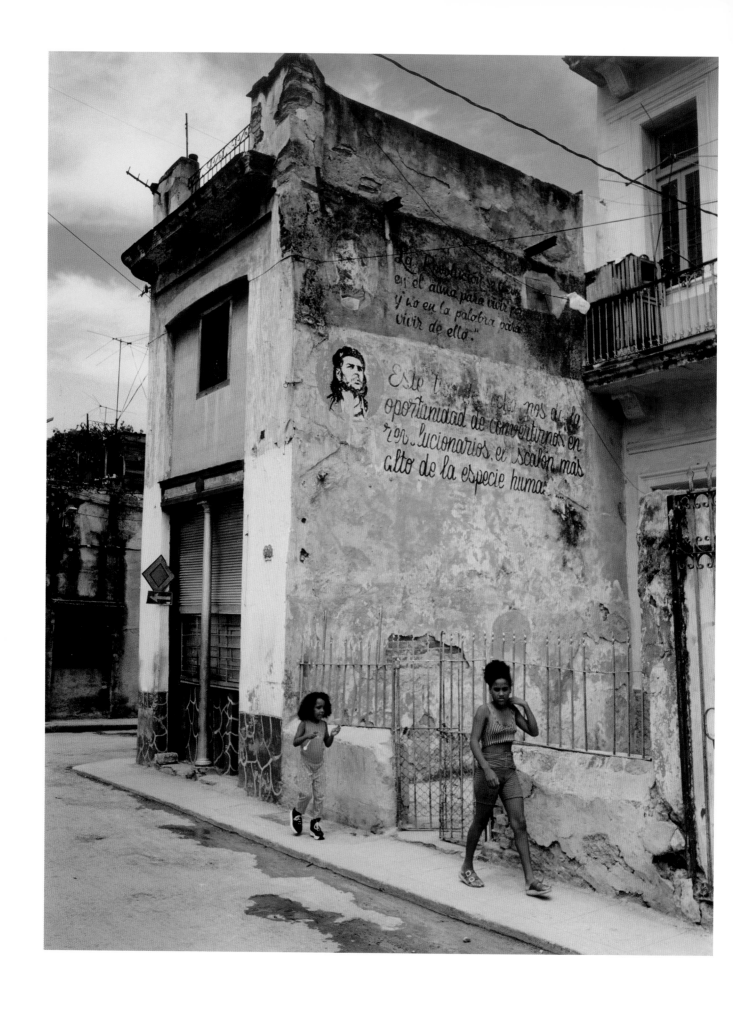

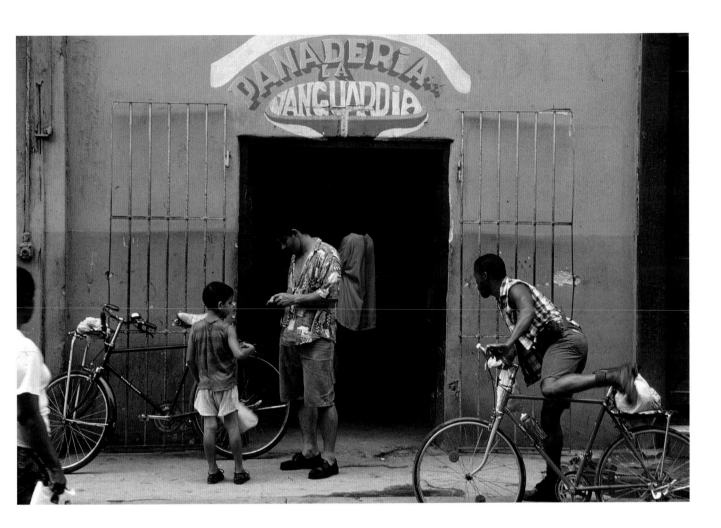

I have lived here just fine because I have sacrificed a lot for this hell of a system that we've got. I am not part of this system at all. And I don't owe anything to the state, I don't owe anything to anyone. Nor do I have debts with anyone, only with God. My only debt is to God, okay? The only one. And I have my children, yes, I have my children. But do I think about Cuba?

Cuba will always be my home even though I . . . You have to jump through hoops to deal with all the red tape.

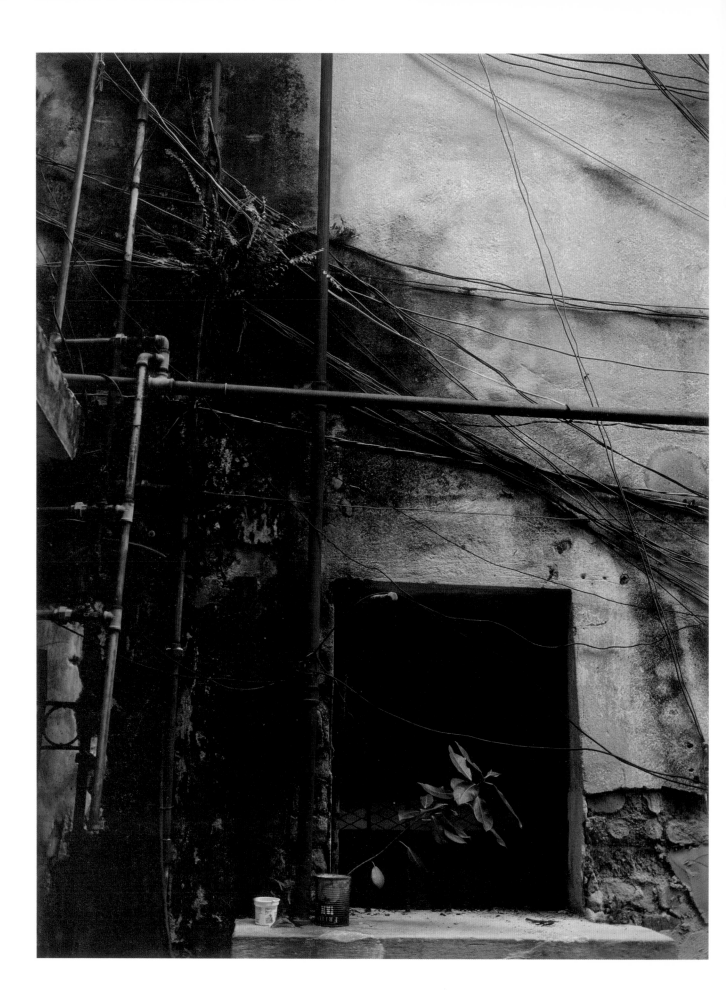

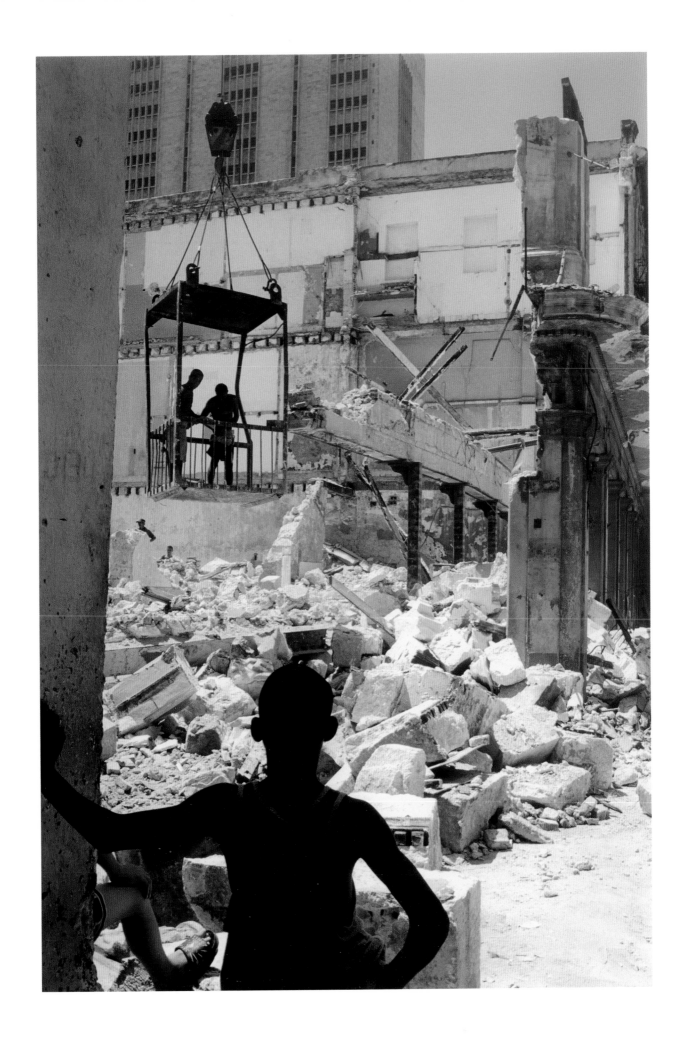

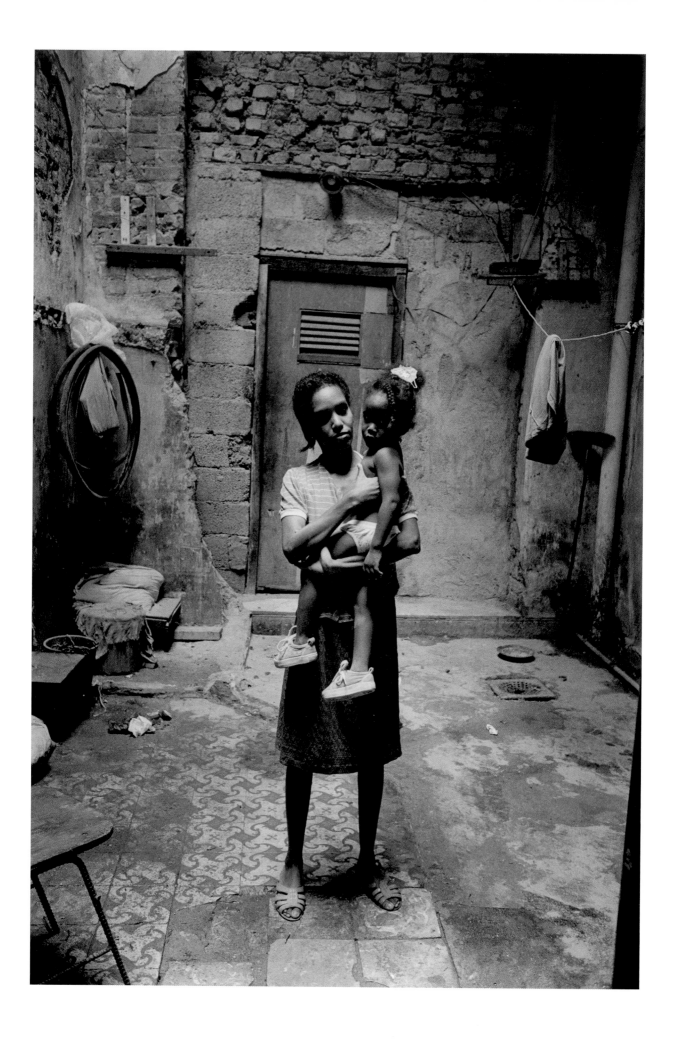

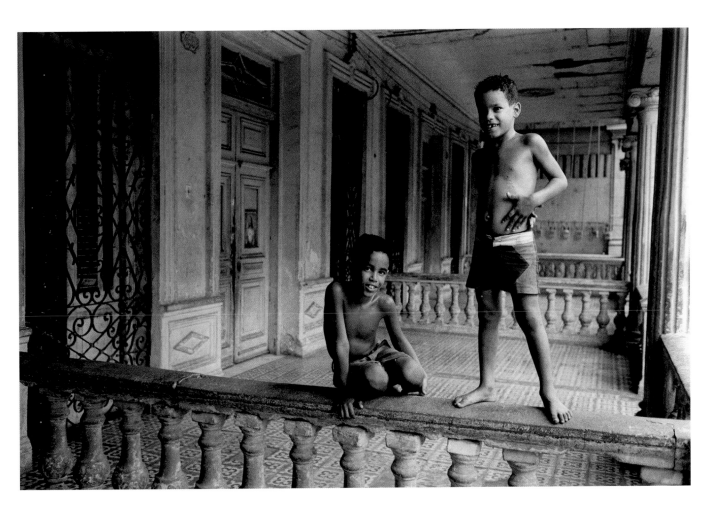

No, it doesn't make me feel bad to leave my house because it's the home of my children. I want my grandchildren to have the house so I'll leave it to my children, which means I don't have to leave it to the state.

It's not that the role of the woman is difficult, but what you've got to do is defend that role. And develop it for yourself. From the time we are little girls until we grow up and are full-fledged women. Because unfortunately, it's us women who are tied to the house. We are involved in everything that's part of the house, like ironing, washing, cooking. We're working so that everyone has food, clean clothes, so that everything's easy. Everything has to be in tune with the way you do things, the way you want to live. And every room forms part of your work as a whole. Ever since I was a girl I took care of my little nephews. And while they were growing up, I was learning, and so when I had my own children I was prepared. I did everything by myself.

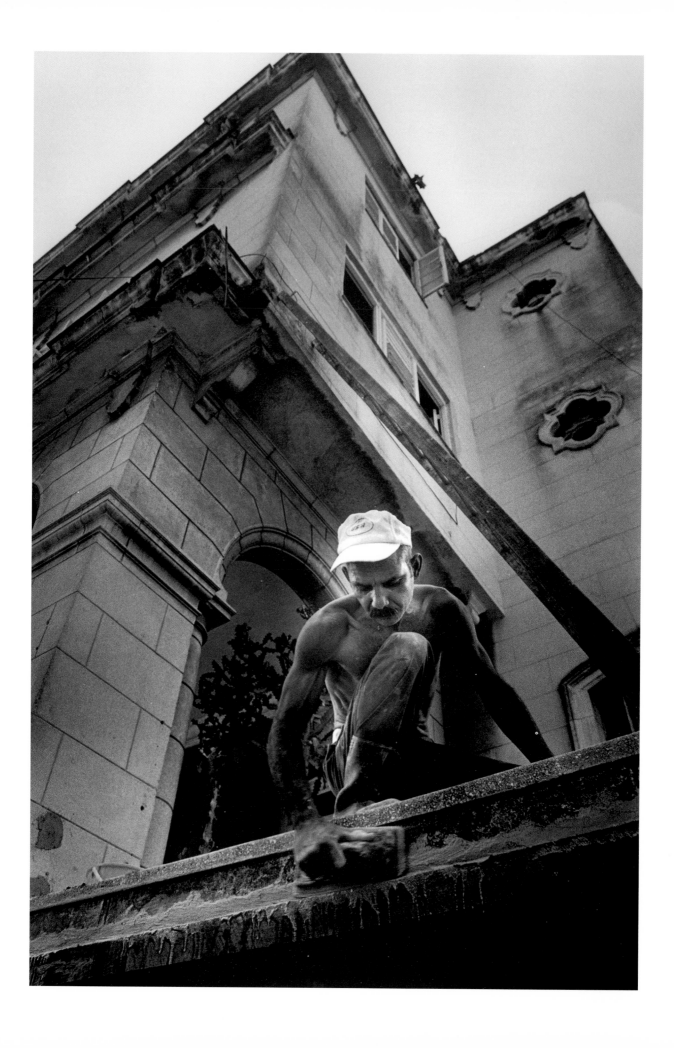

Ah, well, what a house this was. The balconies, the same wooden ones that you see there, that wood below, was once new. It looked like a castle, a castle, you know? Very beautiful. The façade in front, beautiful as a castle. But now it's rundown. The building next door belonged to the same owners and is still like a castle. These two buildings, the same owners. Really strong, really strong, but it's abandoned now, you understand? Like my husband said, this building if you fix it up would last forever, would be great because it was built to last from top to bottom. The bricklayers and all those workers did a good job. Everybody says that. Cement below, it's all rock, stone. All this is stone. And hey, this same building that they're building on the corner, the one they're constructing over there, the tall one there, the foundation, well, they had to break the rock with dynamite, blow it up because it's all rock, dry seabed. Because all this is stone, pure stone. You have to bore down and just blow it up.

No, this job is for the government, or private companies even, big companies. But I mean big, ones that build highways and buildings and that kind of thing. I used to work as just a simple bricklayer.

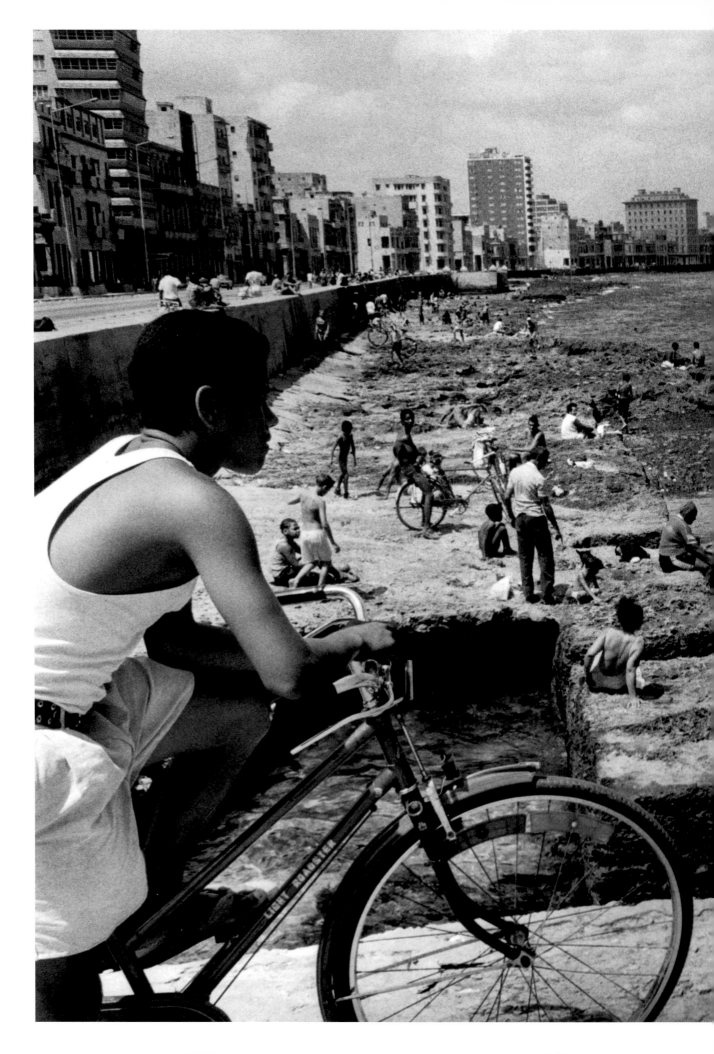

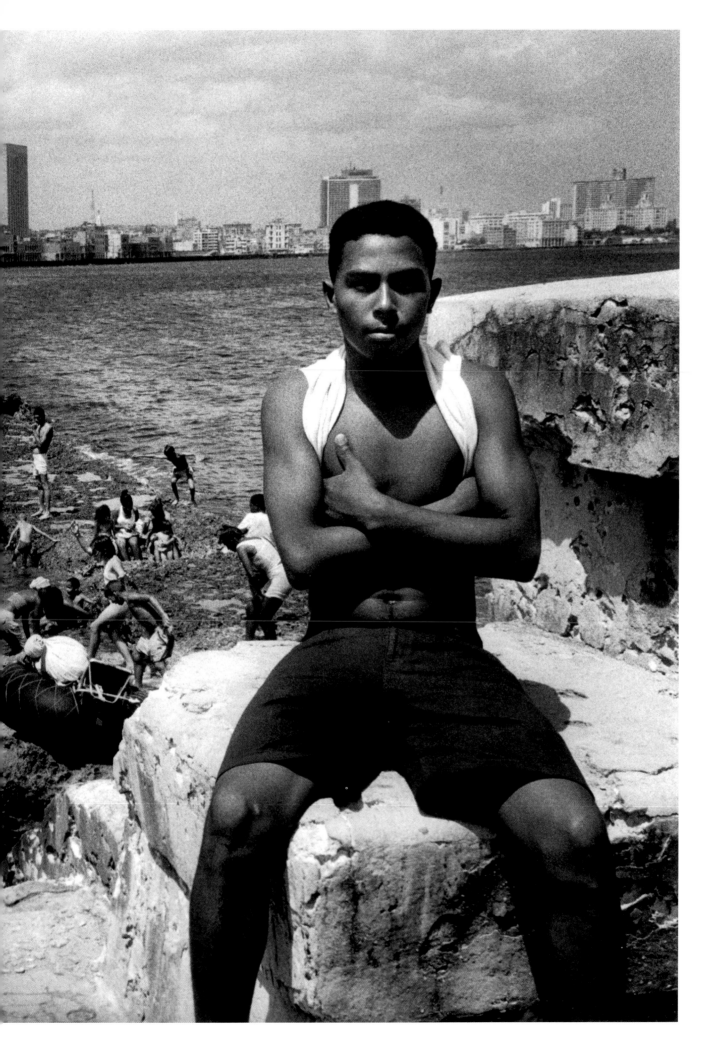

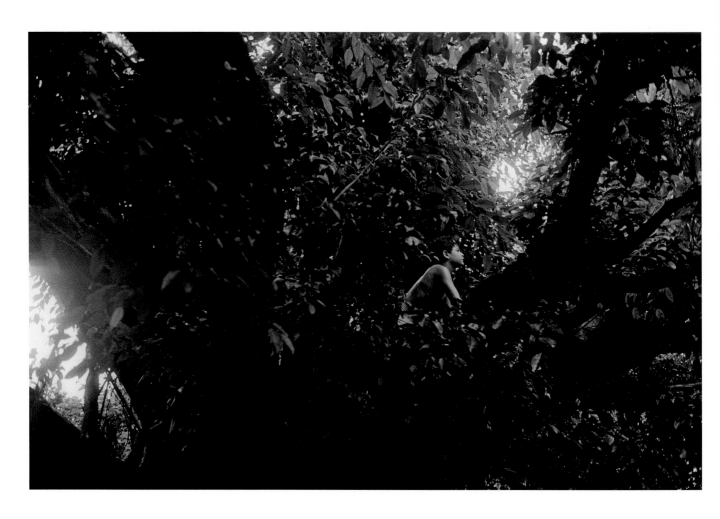

For me a house is like a tree that offers me tranquility.

For me the home is my favorite tree in the park. For me the home is my school where I study and learn something new.

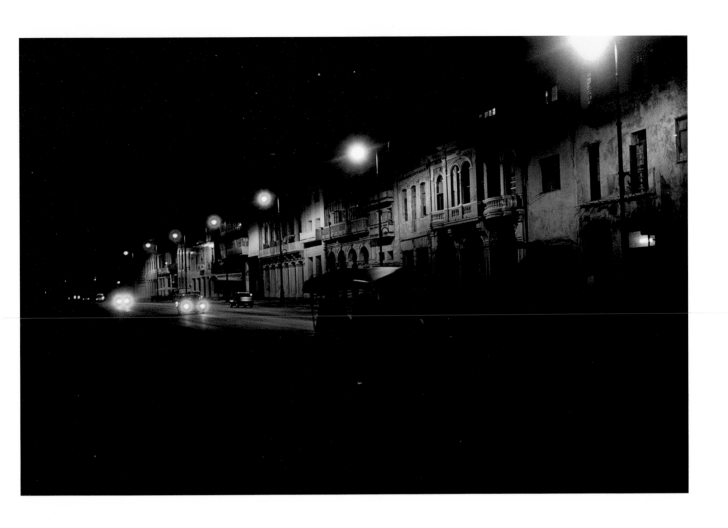

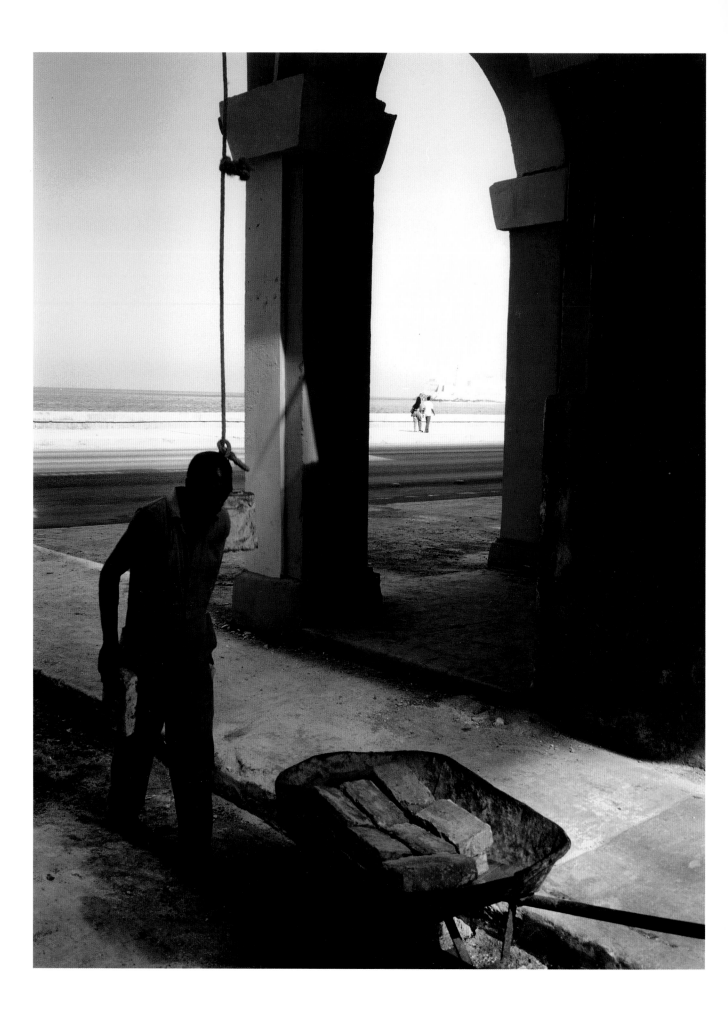

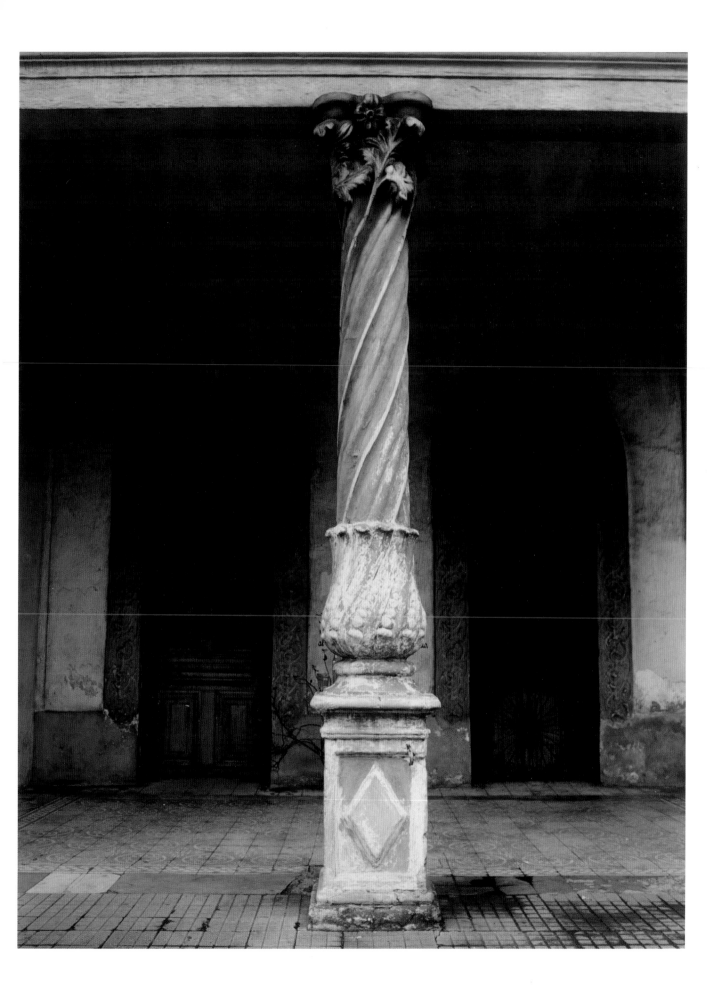

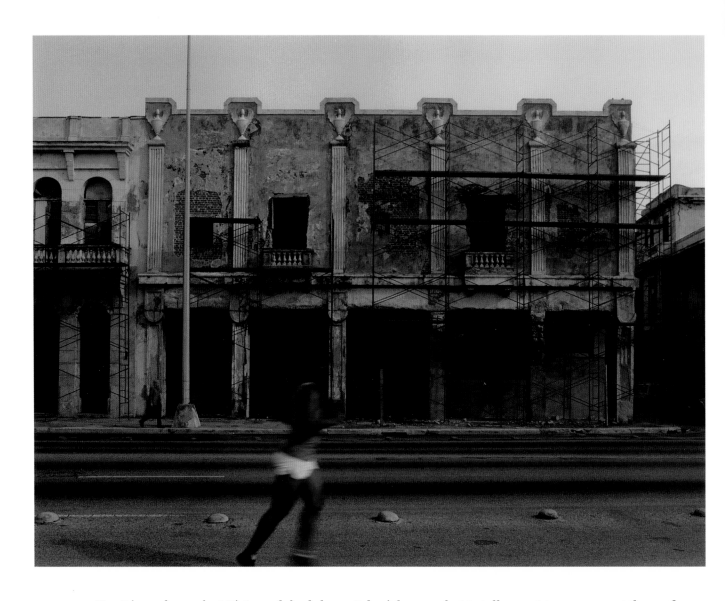

Yes, it's our house but it's in such bad shape. I don't know what to tell you. At any moment the roof could collapse on us. Everything is eaten by carpenter ants. That wall over there, and this one, and everything, everything, everything. That wall there is separated from the rest. What's needed is money, but you've got to wait. It's hopeless. This has been going on since . . . it's hopeless. That wall is dangerous. And so we just put up with it. All the work that needs to be done, the walls separating, it all costs money. We invested our own money so that now it looks better, but it's come to the point of no return. Neither our energy nor our strength are the same as they used to be.

This is not worth 4,000 pesos (US$200). Don't even dream about it. And on top of what we've already spent, all the house repairs that we have paid for ourselves. They overcharged us. And to live here thirty-seven years, how many repairs have we had to make? The kitchen, the back room that leaks water when it rains, the roof, a lot of work. To stop the water you've got to patch up the roof. And they say that there are no materials, and they say this and that. What's needed are basic repairs, just simple things.

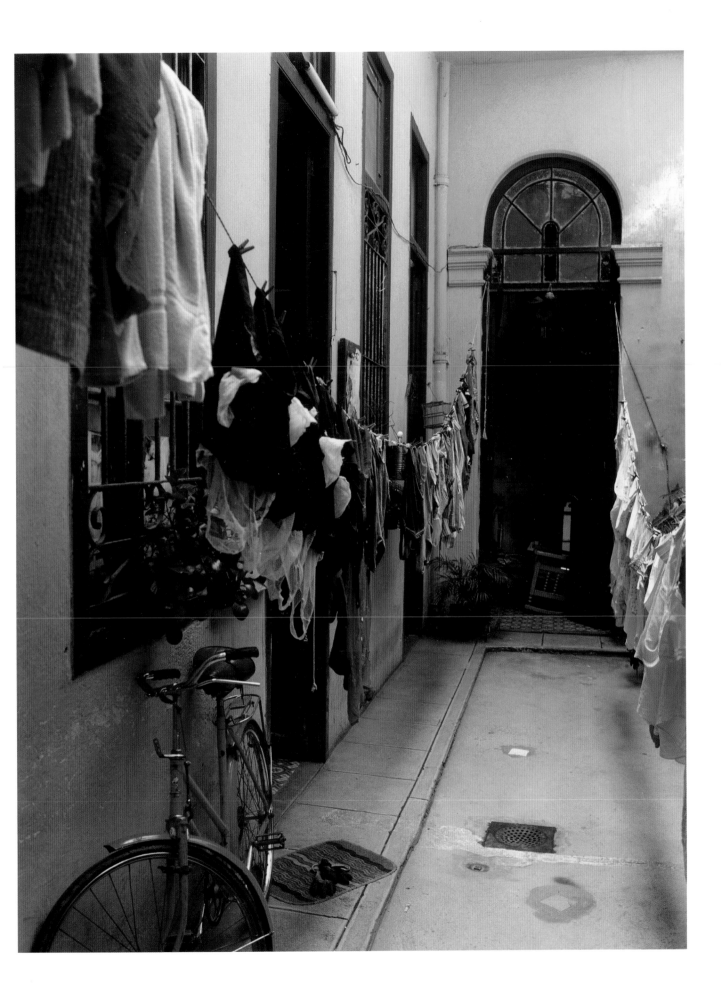

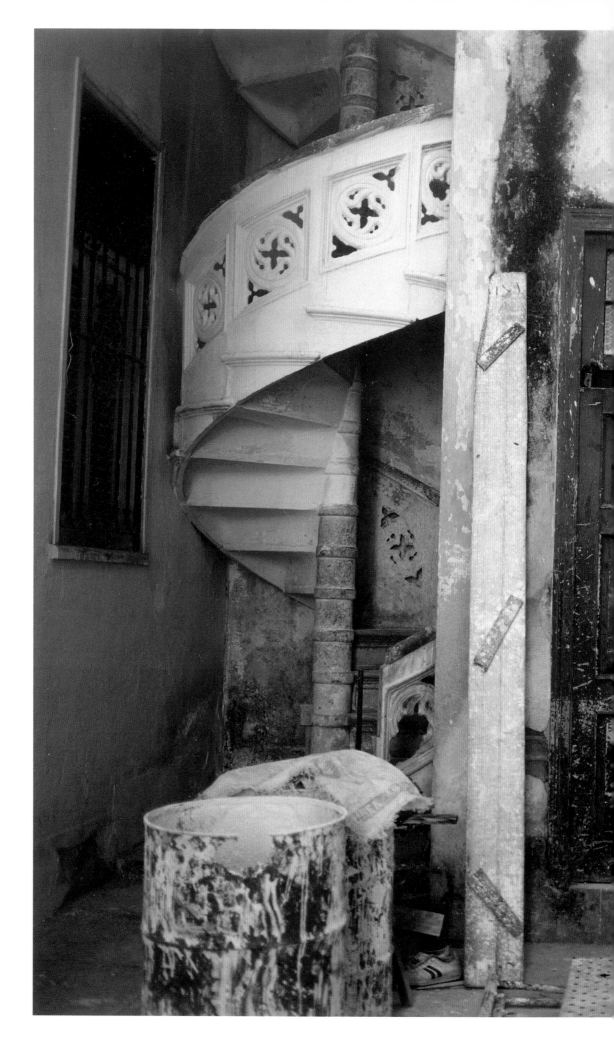

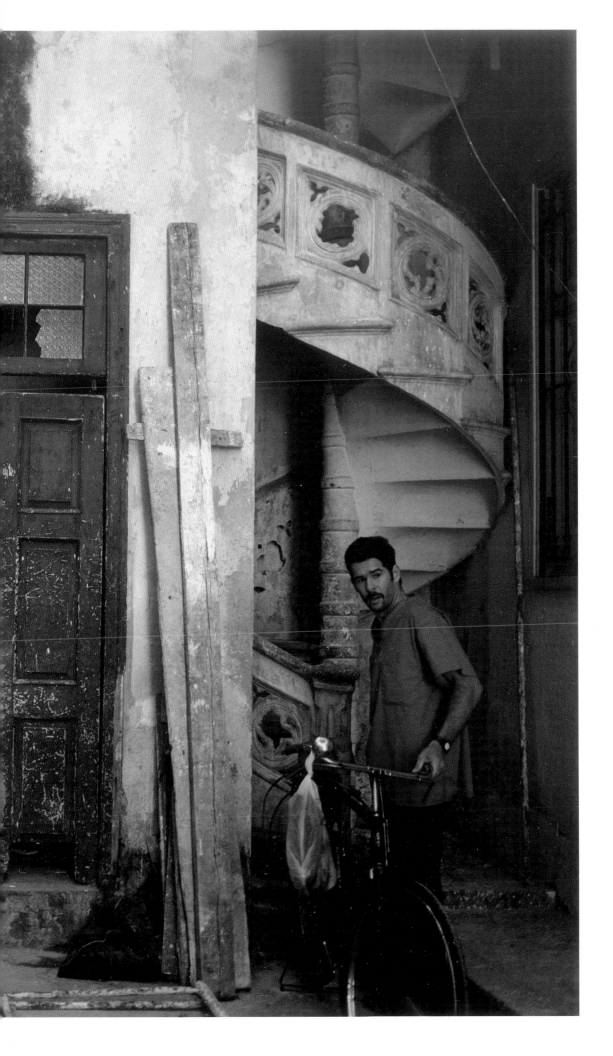

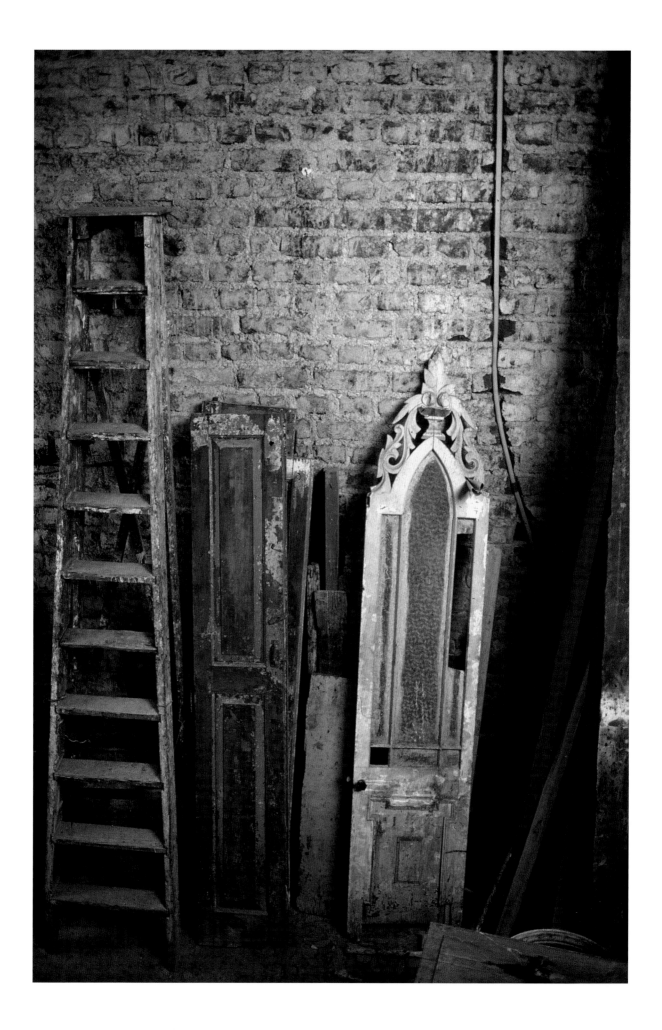

I have three children—one who's twenty, a seventeen-year-old, and this one here. It's different for a woman. My whole life is within these walls. But the youngest wants to have his own room, to have a life, his independence, his privacy. Men need that. So do I. For me, or at least for the children, hell. I would like to have a room for each one of my children—I would like to live in a house the way it should be. At least I have two rooms. You can fix up this house, but you can't live in this house. I don't have anything here. I don't have a single thing here, and right here I don't even have a door. Over there it's ugly and you open the door and it bangs into the fridge. I wish I could have a living room, a dining room, some chairs, a nice table. Not a luxurious house, but with the basics, so that the children could have their privacy, at least when they're adolescents—fifteen, sixteen—they want to have a girlfriend, their own room, and their music here.

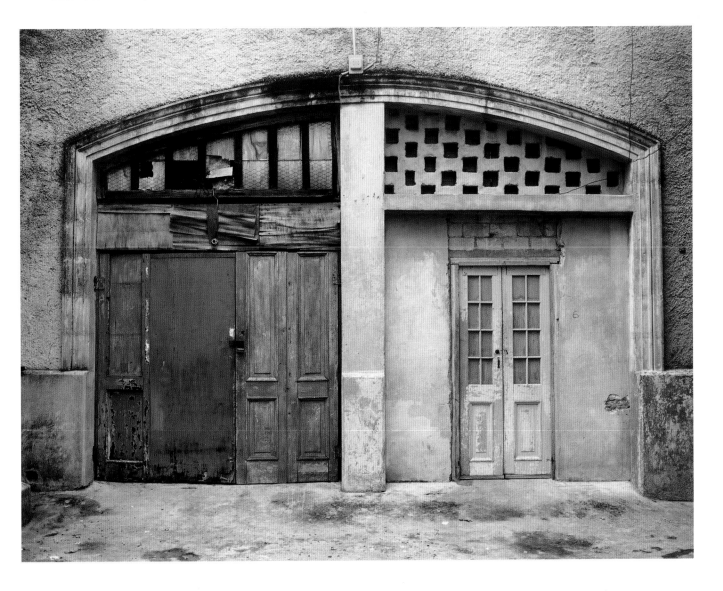

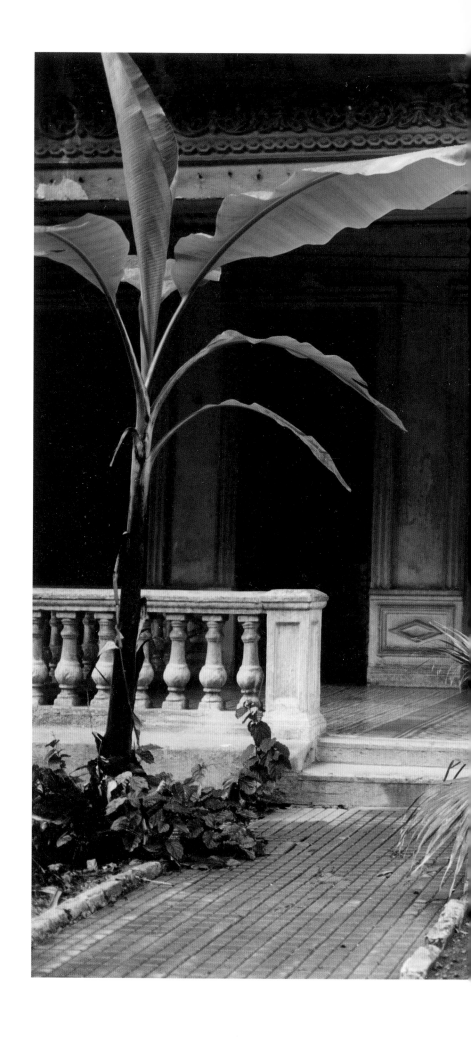

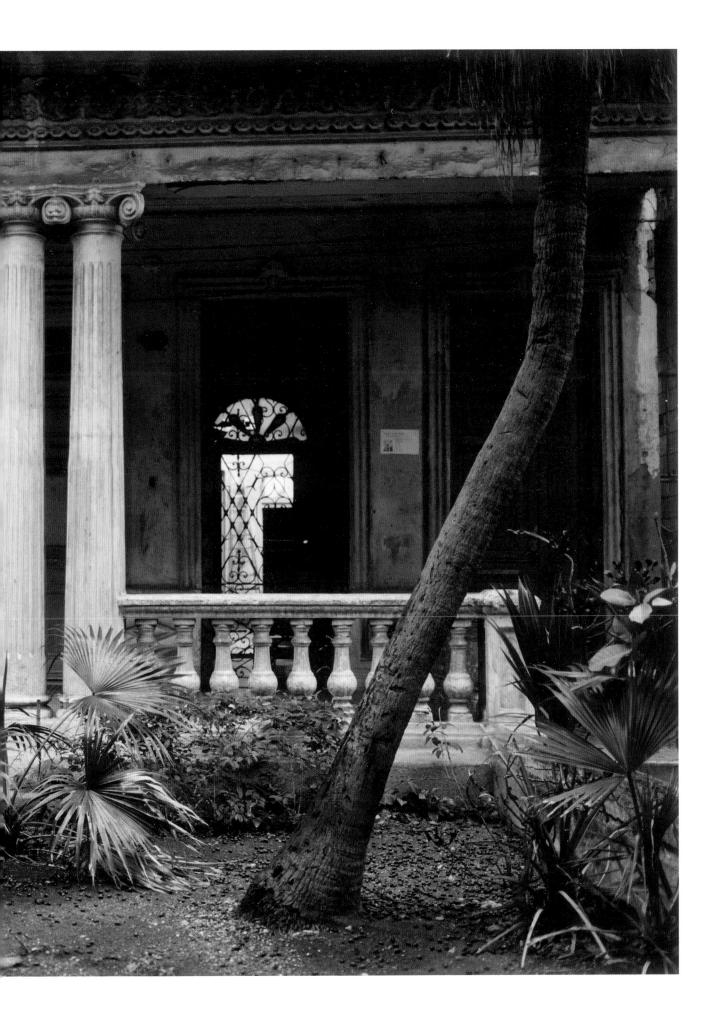

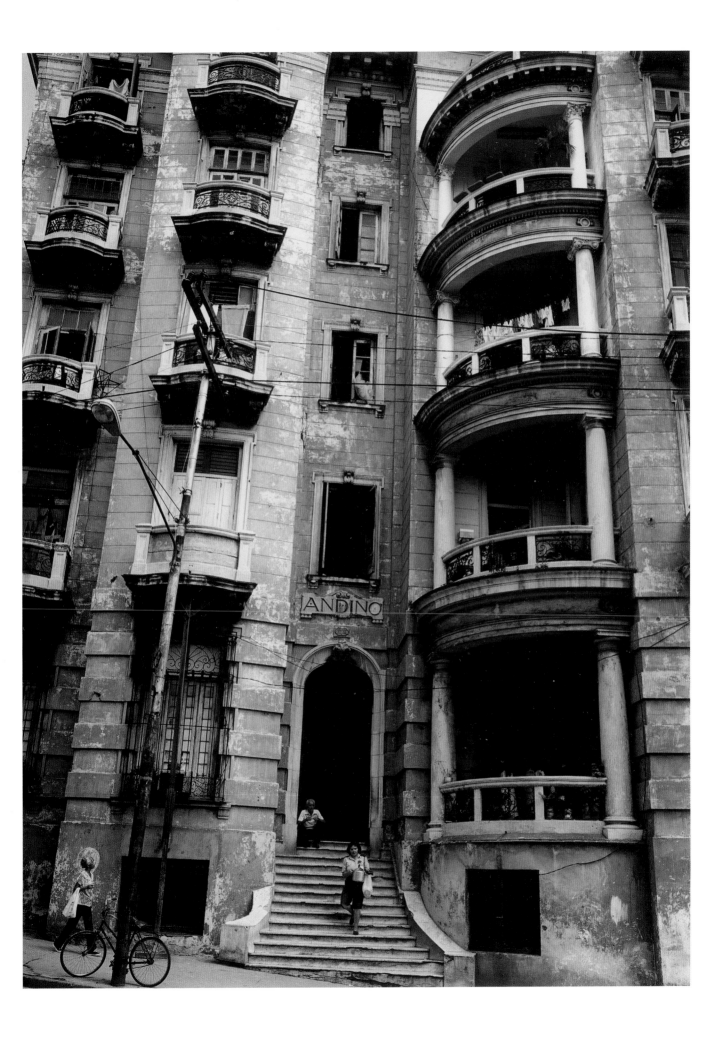

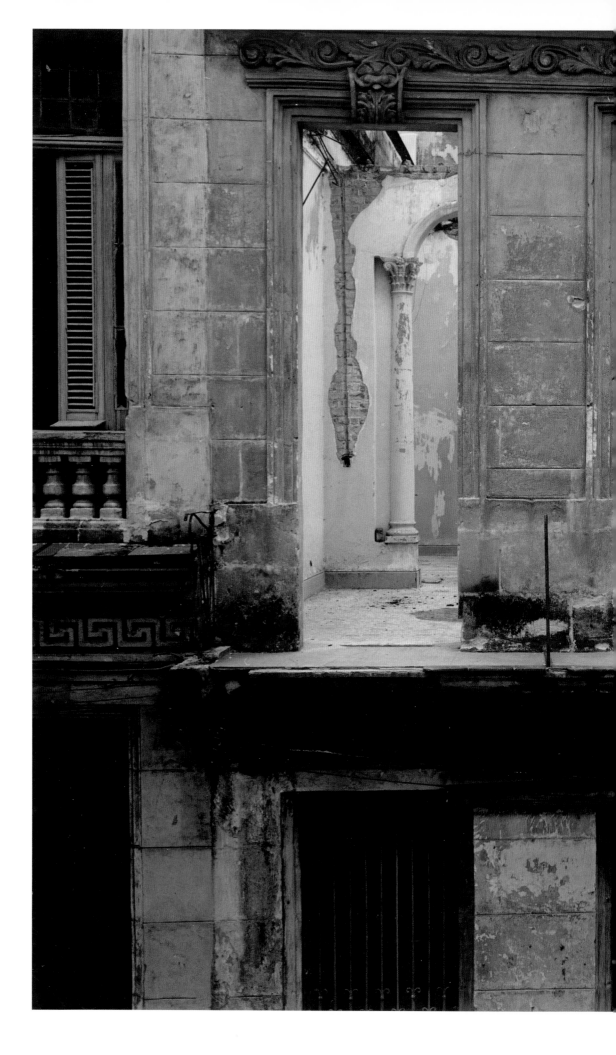

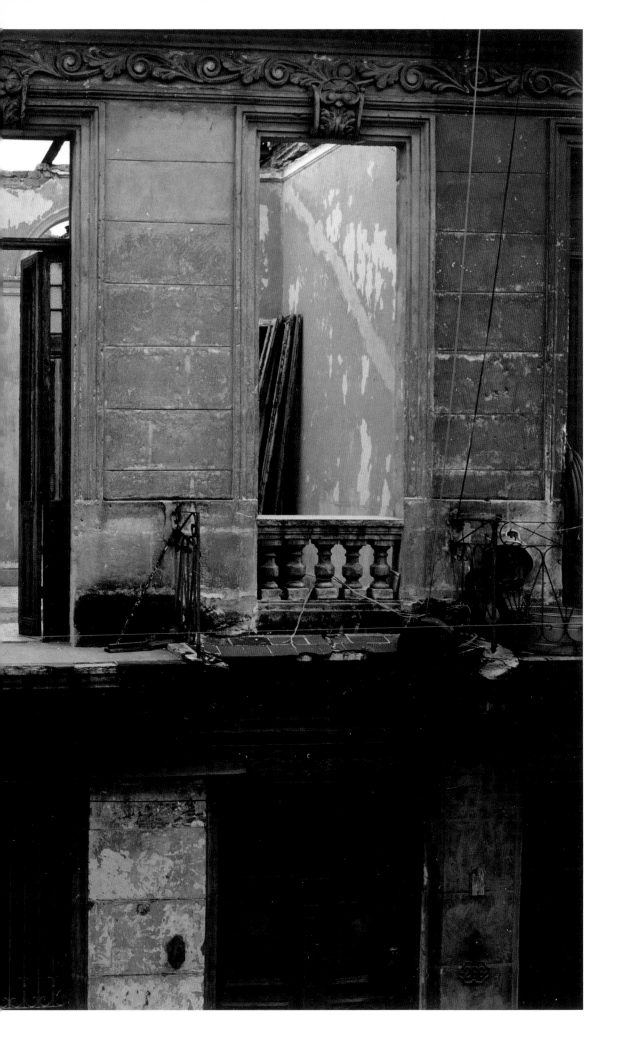

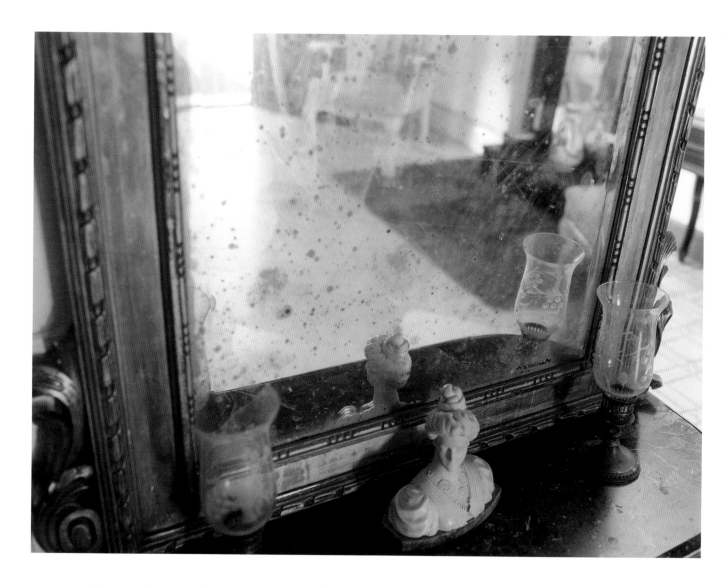

Yes, over there in a little apartment beside mine there once was a man and his wife having an argument. So she took him out on the balcony. The balcony collapsed. He grabbed her, and the two went down together. The two died and left behind six children. A tragedy, difficult. But she was a woman of strong character. And with six children you can't live under such conditions. But someone has to take care of those children—it was a responsibility for her as well as for him. And nothing was ever heard about them ever again, and that's hard.

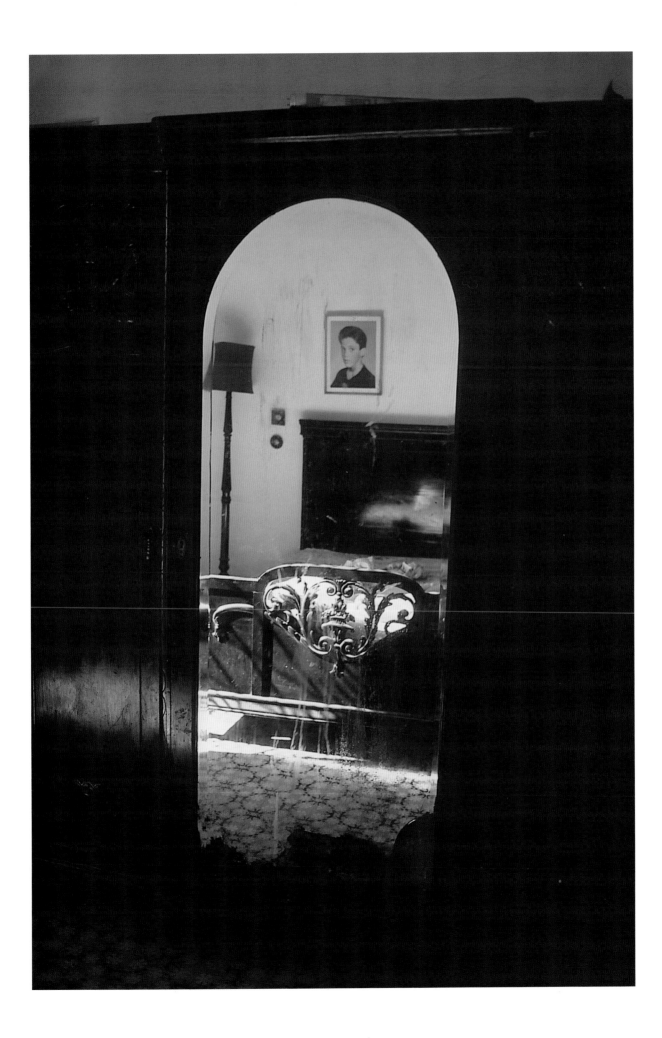

Martí was a genius. He embodies the past of Cuba. Through him, we find our sense of home.

He strove for equality, brotherhood. That's what Martí was looking for, and it's really what the Cuban people should have worked for. These past few years have really twisted the Cuban way of thinking.

Well, when I studied, about forty years ago now, José Martí was known as the "apostle of Cuban Independence." With the triumph of the Revolution and the advent of this system of socialism, the word "apostle" became tied to the Church. So they gave him the name "hero of the Revolution." Martí is recognized as a national hero. To this very day his spirit is felt in almost all the important Cuban political events because Fidel gives the majority of his speeches in the Plaza de la Revolución, right below the statue of José Martí.

There are still people that are moved when Martí speaks of family love, brotherly love, the love for all people. . . . Well, paraphrasing him, because I don't know exactly the right words, Martí dreamed of the day when all people would pass by one another and kiss one another in a gesture of love and friendship. That's what he wanted to see happen. He has some incredibly beautiful pages dedicated to brotherly love and friendship. He felt passionately about his family. . . . He made his living as a journalist. As a translator. As a poet. He wrote theater pieces. You could say that he supported himself through distinct facets of cultural activity. And he left everything aside for the struggle for Cuban independence. He is respected. The things that he wrote still have resonance. I have said it myself right up front that he, as much as Simón Bolívar, were looking for panamericanism and the union of the Americas, nothing less. And I will say it again, that what José Martí left undone, still remains undone. No one has done it yet. The dream of Bolívar or of Martí has not been achieved. What those men did not accomplish has still not been accomplished.

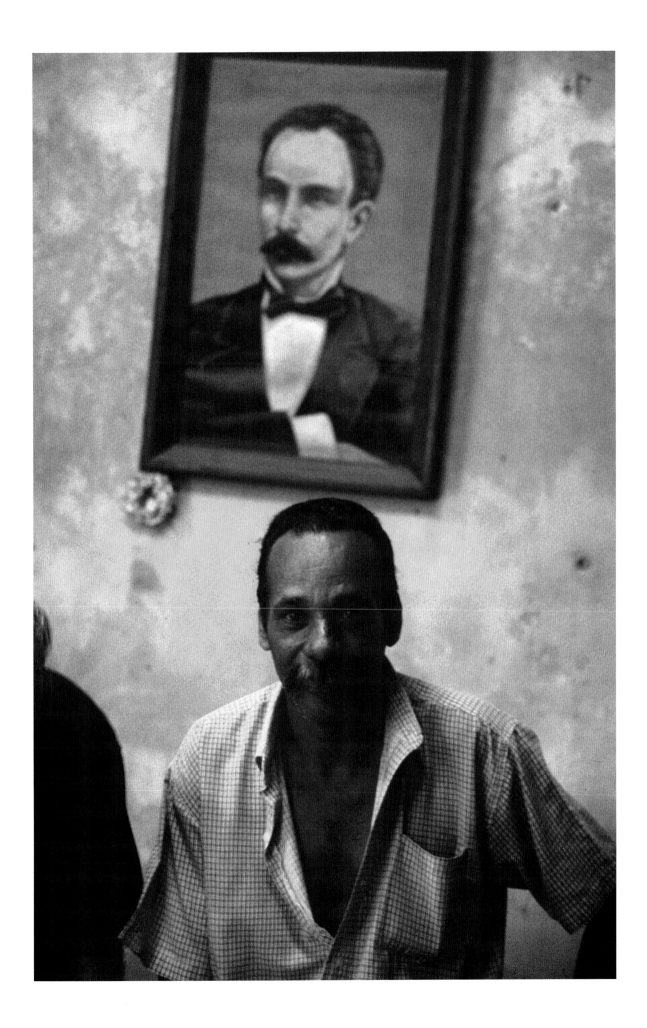

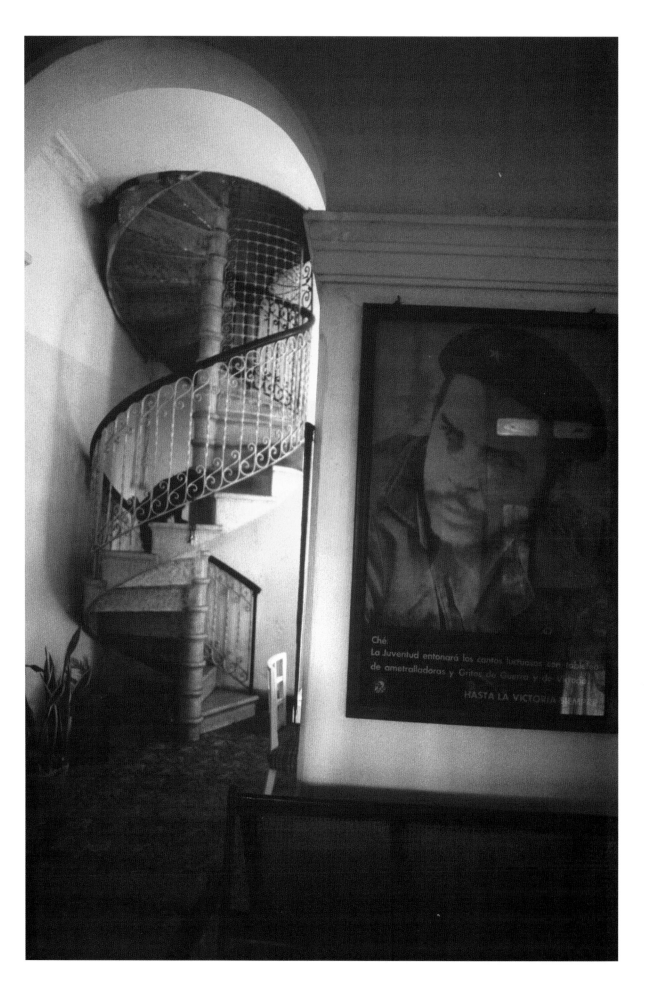

Ché.
La Juventud entonará los cantos luctuosos con tableteo
de ametralladoras y Gritos de Guerra y de victoria.

HASTA LA VICTORIA SIEMPRE

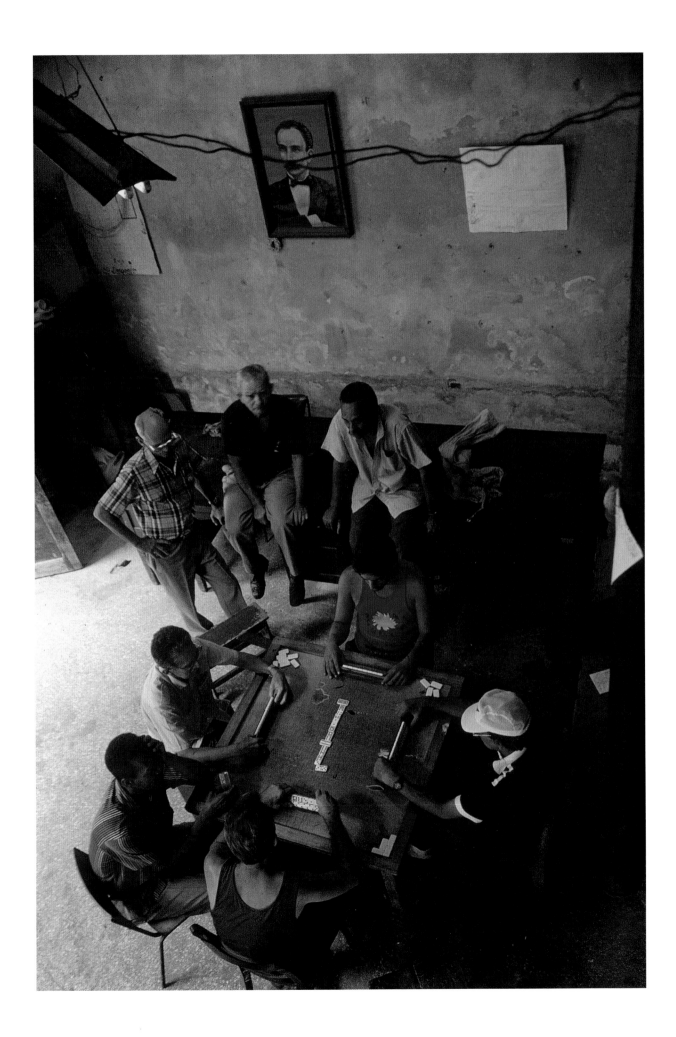

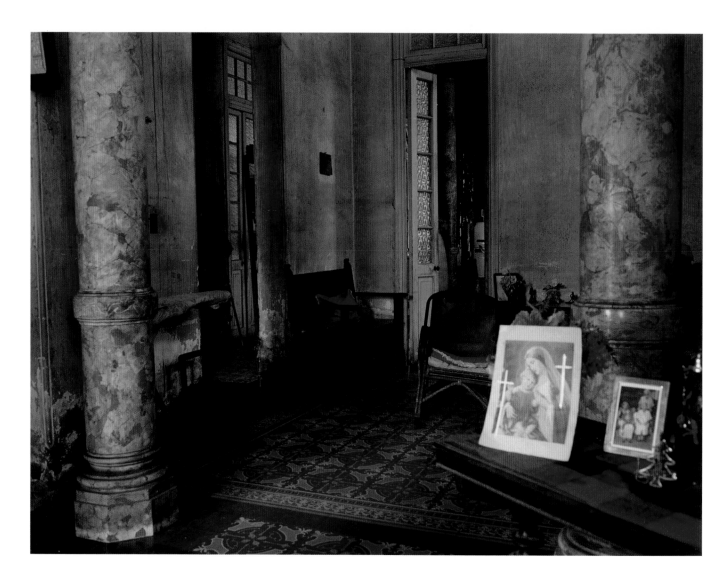

Human dignity, one has to take care of it.

Every society has its problems. We have ours, let us live them. Freedom. I have nothing to do with the state. I work. Look at the bicycle I use for work. Now wait a minute, I am not complaining. The tire's bald, it has no rubber left, and I don't have the money to buy a new one, but I forge ahead with no complaints. That's what I've got. I don't have any choice.

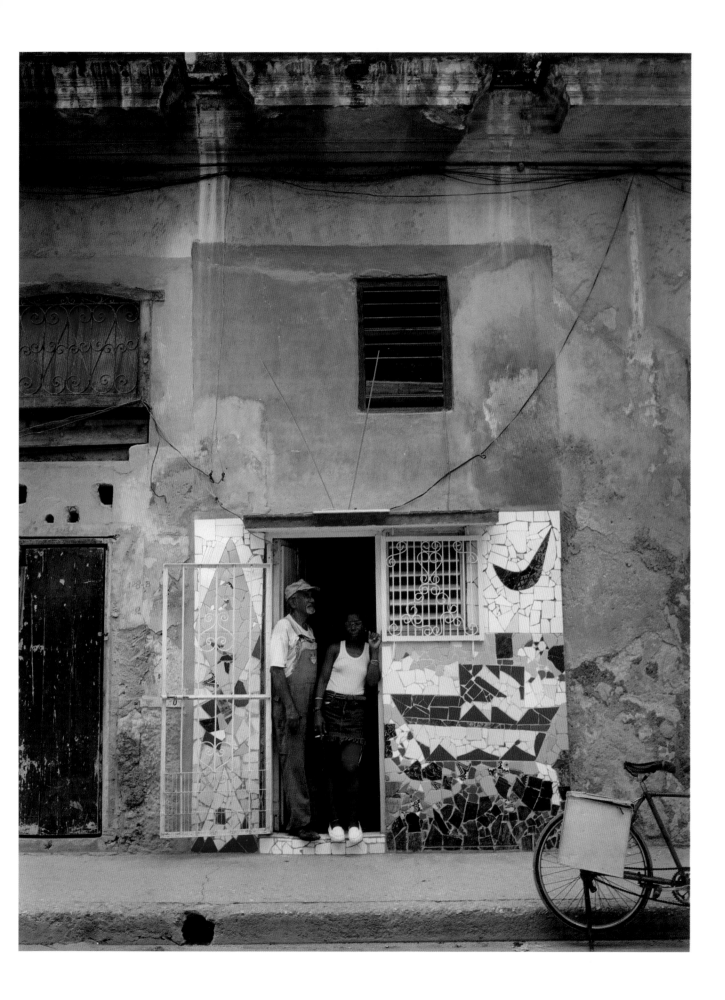

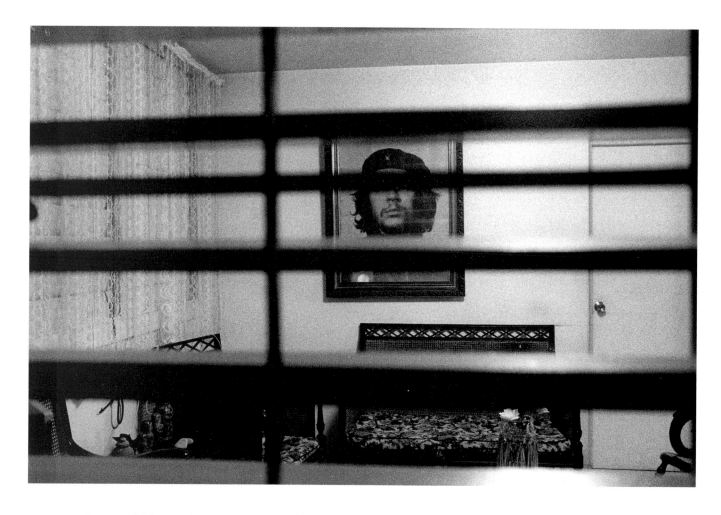

For me the house is very important because it's what I like the most. It's difficult because I have no illusion that I can have all the comforts that I wish I had. But you need the basics, the fundamental, which is food. To have decent conditions and to have food. And there are things that I like and that I can't buy because I don't have enough money for them. Because I earn only about 100 pesos ($5 a month). My husband earns around 80 pesos ($4). And there are expensive things that I just can't buy. Aside from the fact that I don't have the proper conditions because I don't have a fridge. This is one of the things that bothers me most, not having a fridge. Because how do you store food? And it's been that way, for how long? About seven years. Without a fridge. What can I do? Every day I have to buy food if I've got the money for food. The most difficult is the cooking oil that you have to buy in the mall where they only take dollars. Oil costs about 20 pesos ($1) for just a little bit, and then some tomato sauce, and decent bread, and there goes my 180 pesos. This is a tragedy, nothing more than this. The daily struggle is not easy.

For me the most important object in the house is the refrigerator. This is the most important thing in any house. You can watch a TV anywhere. But the refrigerator is essential to a house. Because it's the fundamental place where you keep the meat, and the water cold. Without it the baby's milk goes bad, and everything spoils. The refrigerator is essential.

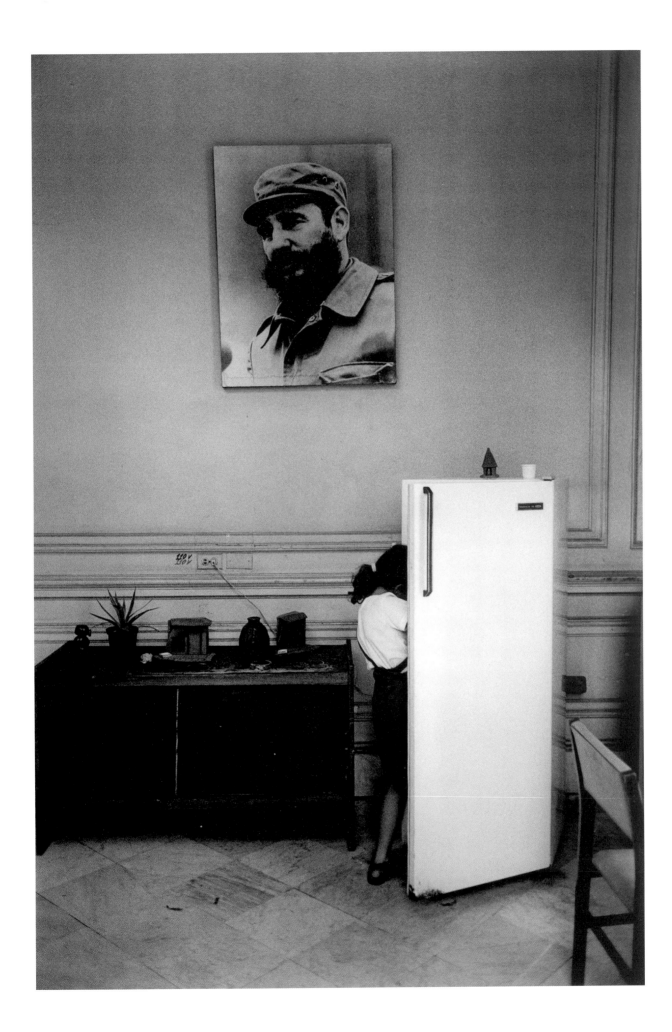

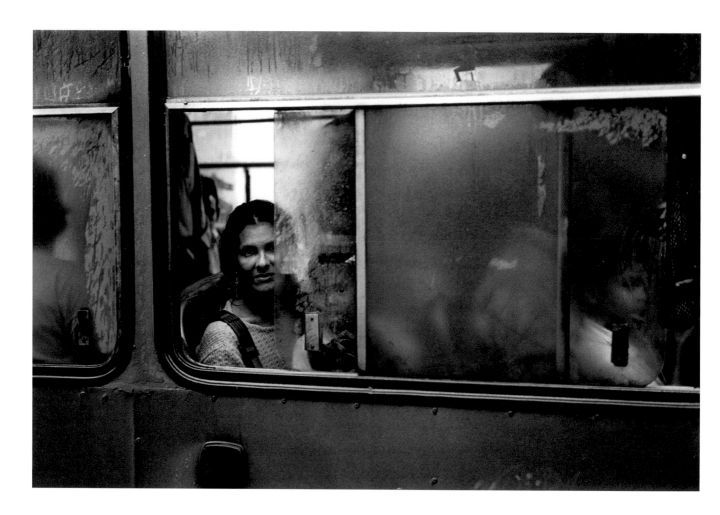

Without my family I am nothing.

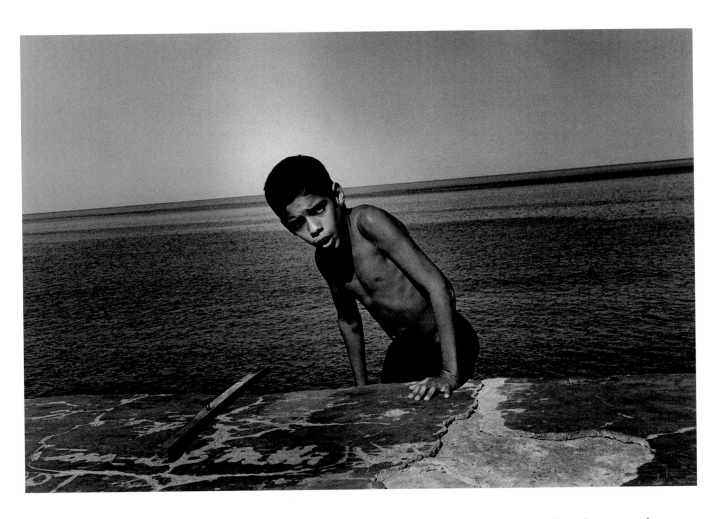

You feel at home when the breeze from the Malecón comes into the house, or when there are other people here. When we're all here and we feel the smell of the sea that comes right in here. What a rich, deep smell! What a fine breeze! It makes you feel good. It's very wonderful. The heat upstairs is unbearable, horrible, you know.

We always keep the door open for ventilation and everything. That way the street is like another room. We're out here sitting, feeling the breeze, and watching the people. You have to be outside too. To be in the thick of things, as they say here in Havana.

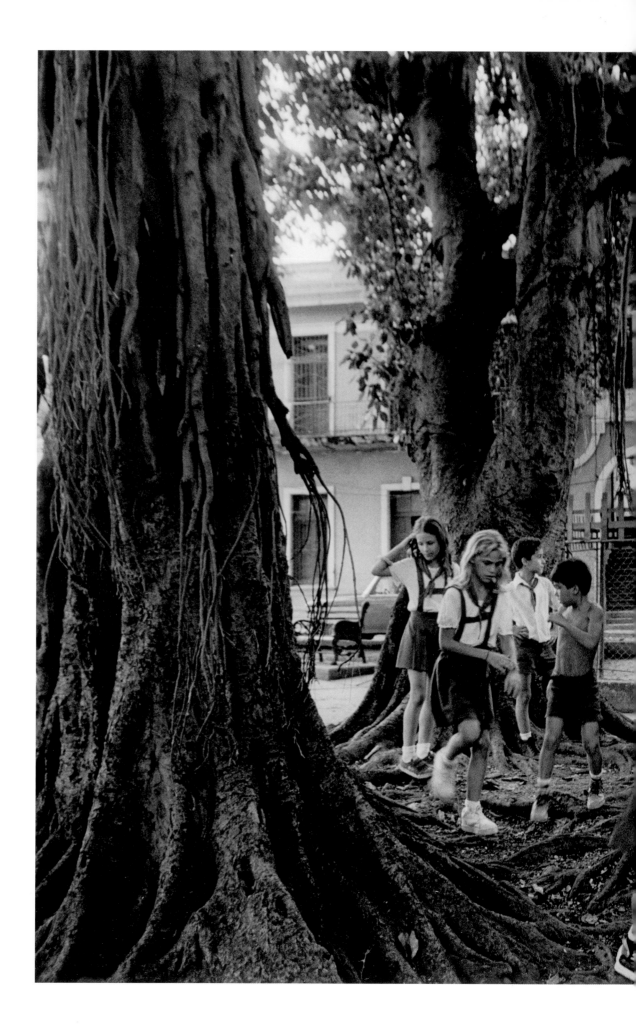

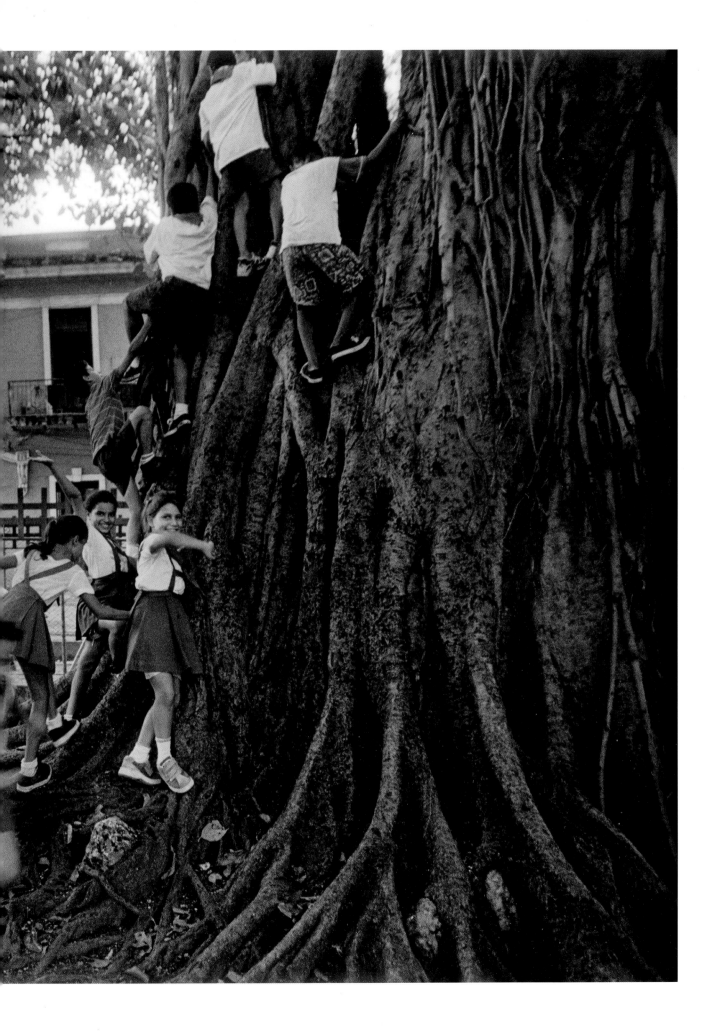

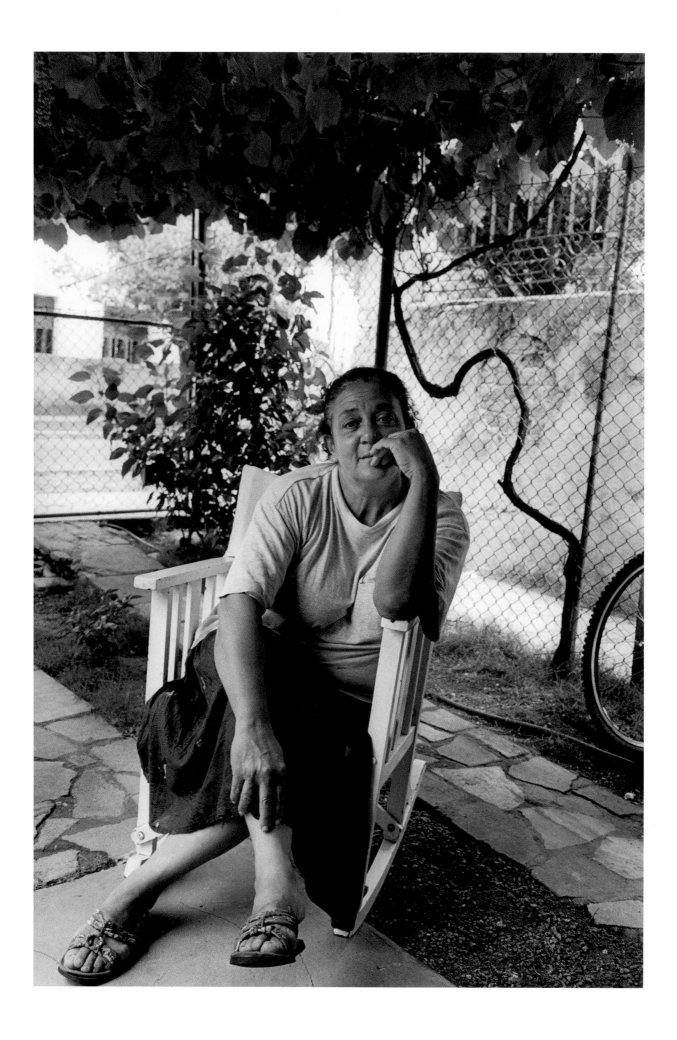

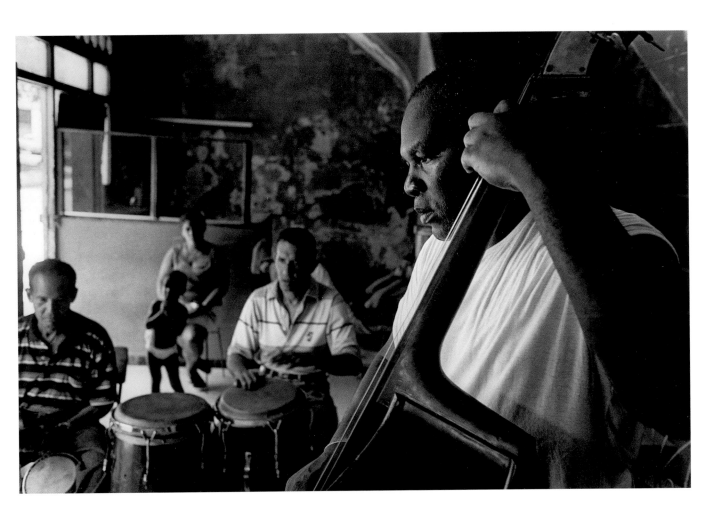

The grapevine fascinates me. It's like a little house out there with its roof, with its shelter. It is very stimulating, very pleasant, a symbol of life, of everyone's life. The grapevine represents everything for me. I like it a lot, a lot. So here's how I got a plant. One day I was going to work and I meet this man who greets me every day, and just like that, spontaneously, we say hi and he says that I've got to know that he has a plant for me. So we plant it, and almost immediately, as soon as it's planted, it opened up in an extraordinary way, and grew, and became what you see now. Everybody passes by and celebrates the grapevine and asks if I'm going to give them a piece to plant. And they say—what a marvel!

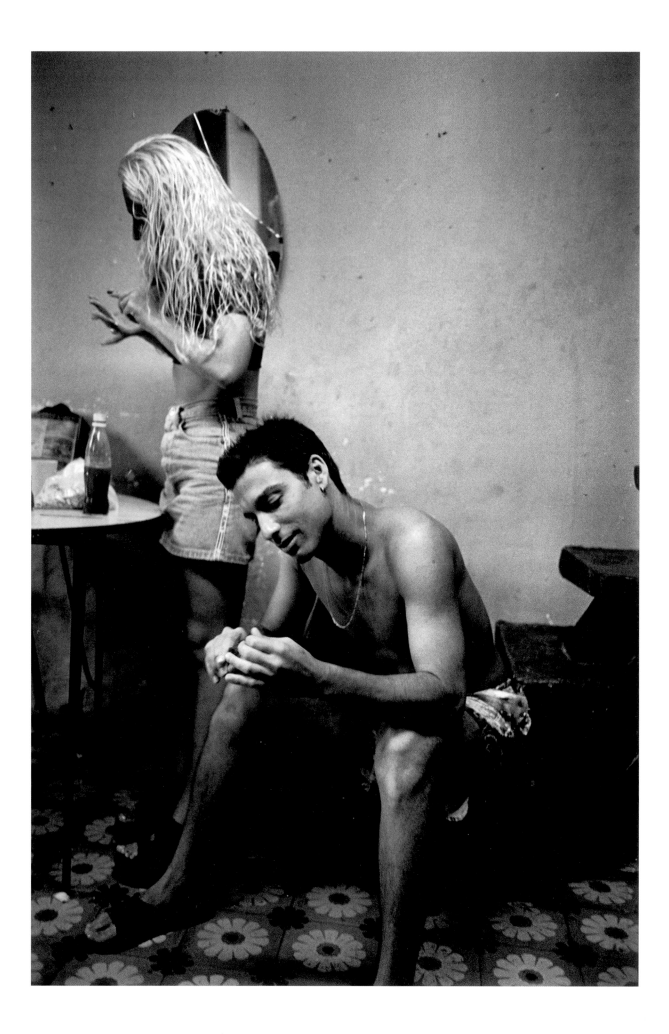

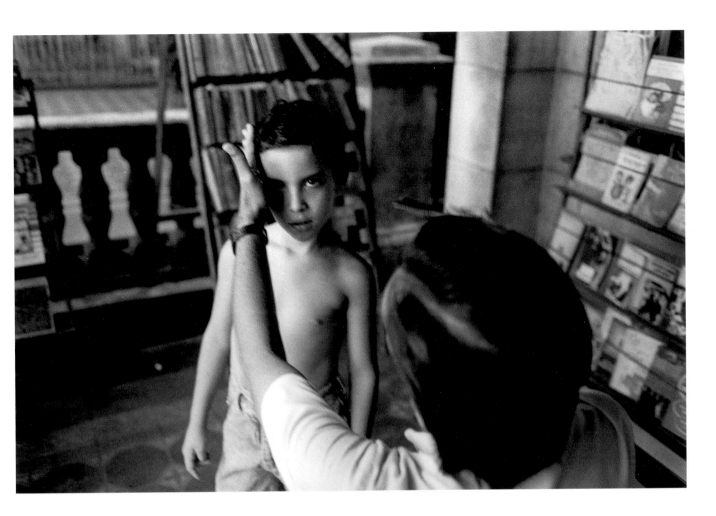

With the arrival of my daughter and her child the house has gotten smaller, but we feel better, more interconnected. And the sense of family is better. The family is stronger and there is a common factor of taking care of this child who was born and is now so defenseless in the world. And it's us alone who have to take care of him and feed him for the moment and make him into a good man. The home is where you live, but it's where you love as well.

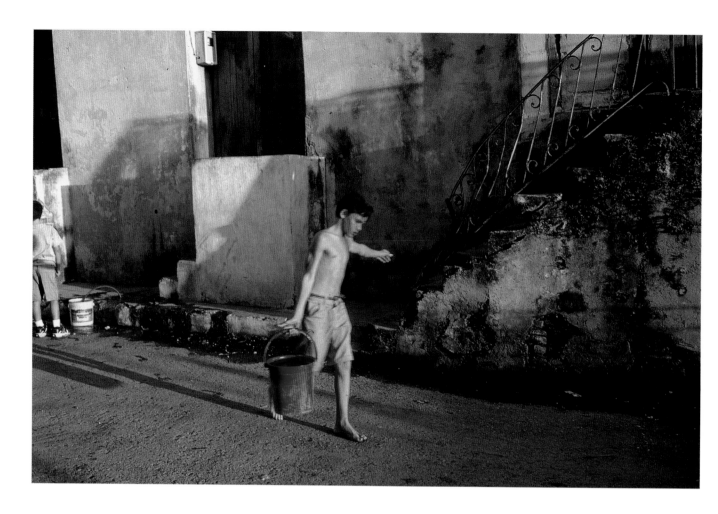

For me, school is my home because of all the time that I spend there, and I enjoy myself with my friends.

For me, home is the school where I spend practically the whole day. And every day I learn something new.

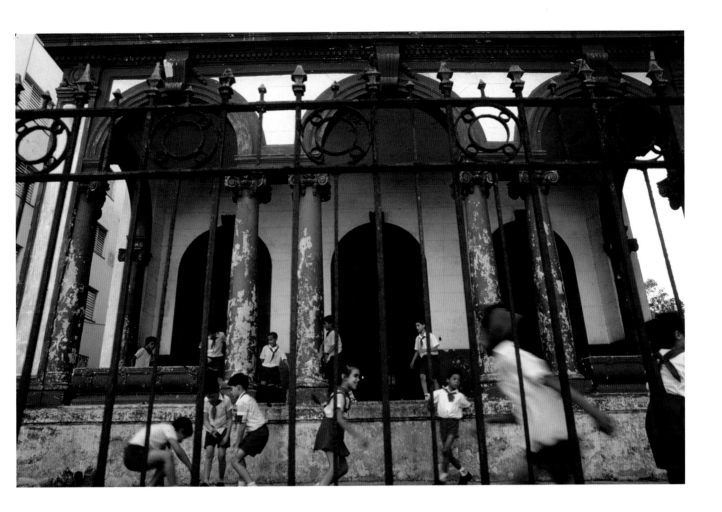

José Martí wrote something for children he called *La edad de oro* [The Golden Age] where he speaks to children about the future. Martí speaks to the child who in ten, fifteen, twenty years will be the man who will hold the reins of his house and his country. He does not speak in a childish manner, but rather in a simple language. He speaks thinking of the child who tomorrow will be an adult. And it's for this reason that *La edad de oro* can be read by an eight-year-old or by a hundred-year-old man. I am fifty years old, and after reading it an infinite number of times there are still moments when I pick it up, open it, and enjoy any one of the stories that are there because all of them teach us something. It's a child's bible. That's where Martí's philosophy is.

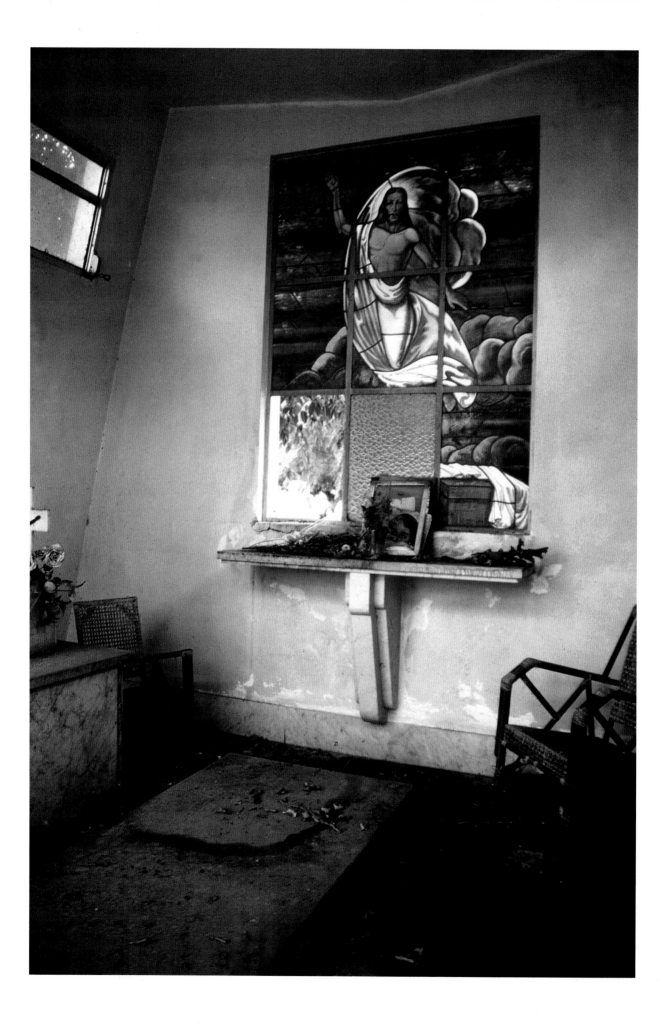

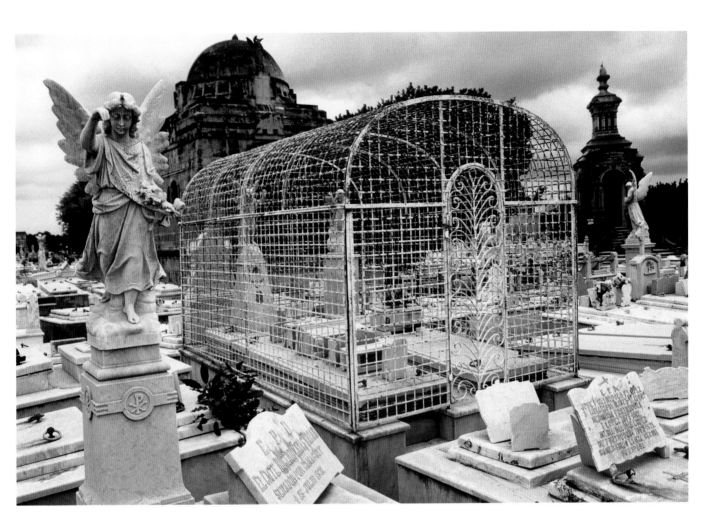

I am very religious. I believe in God. This crown belongs to a saint called Oshún who is the guardian of the graveyard. Yes, I like Oshún. I like him because he is a tender saint, or sad, or gentle according to his *papaquín*. That's his story, that he lives in the center of the graveyard. There one is not alive. No one wants to be dead, but there in the graveyard Oshún lives, long-suffering. So, people who are alive think about ambition and money, but the dead do not think anymore. They have peace and tranquility. I don't know what to think, but because of my age, I have suffered since I was a little girl. I learned to suffer alone because I didn't have anyone around me. I found a refuge in Oshún, and so, if one day I could truly become religious I would take refuge in the graveyard with Oshún where there is peace, tranquility, harmony.

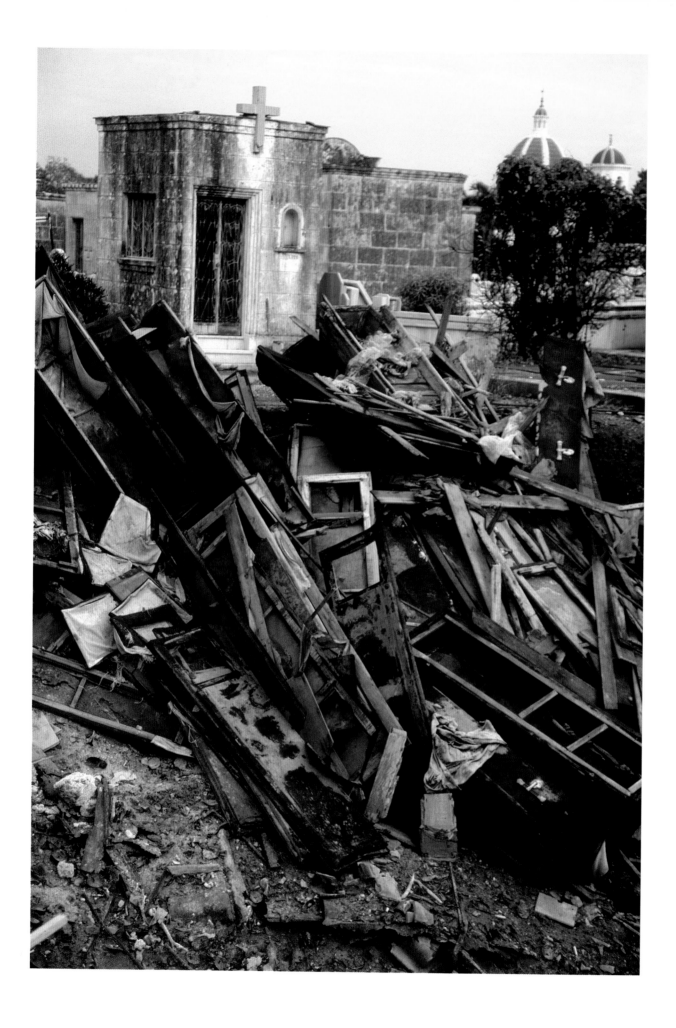

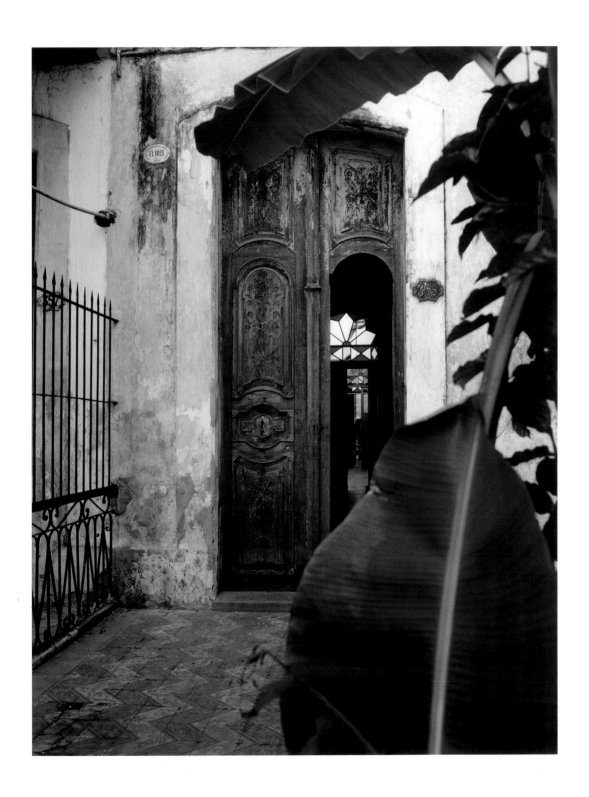

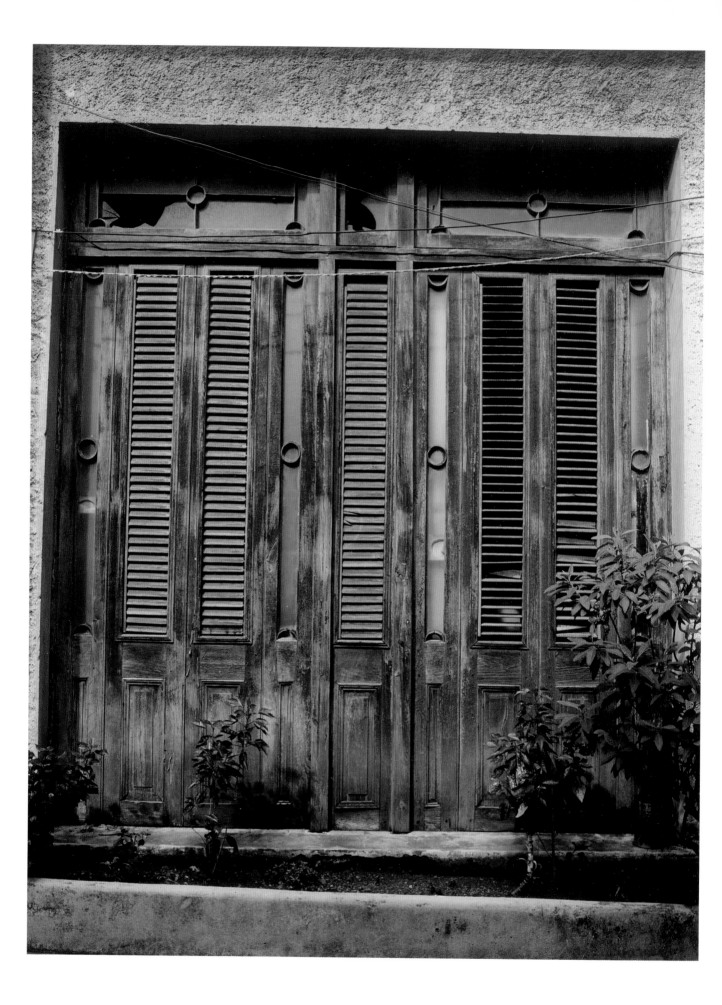

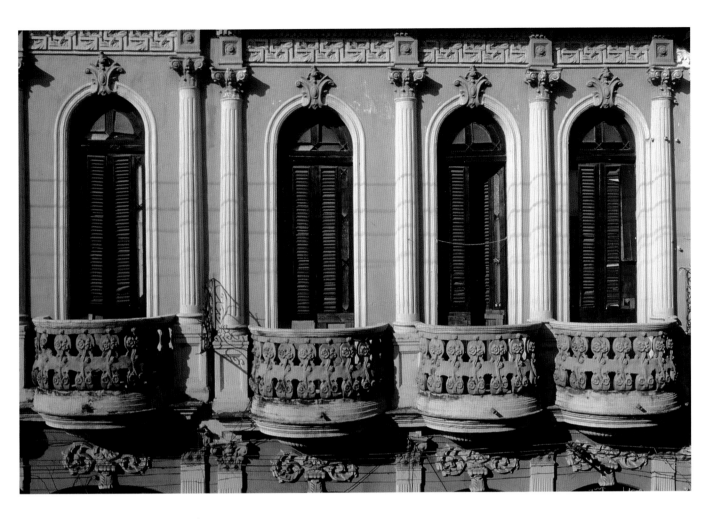

So when the law of giving out property came in '61, an inspector came here and told me that it wasn't my job to charge rent because no one would pay anymore. But I have paid. Not them, though; they didn't have any money.

My dream house would be a marvel. A house with doorways with plants all around them. A house like that is very airy, but mine is now very deteriorated, and you could fix it, but materials are scarce. They don't give them to you, you have to buy them, and you're overcharged and, well, I can't afford that.

We were strong, two newlyweds. Everything was very beautiful. We have spent a lot, a lot, and we have worked a lot—the best years of our youth are in this house. And the work we did was the best we could do. The environment where you live should be the nicest possible because it reflects your life—and it's the place where you spend most of your time. We have retired here, and as you see, with the public transport you can't go out hardly anywhere. You have to walk. Everything is very difficult, so we have to stay here in our house.

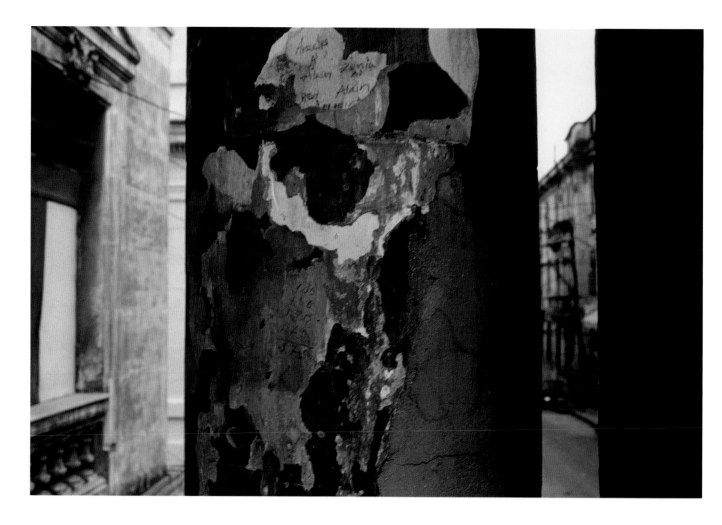

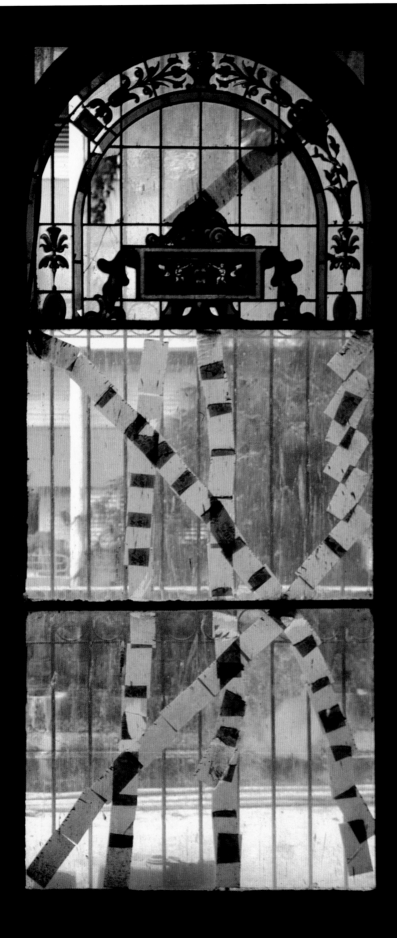

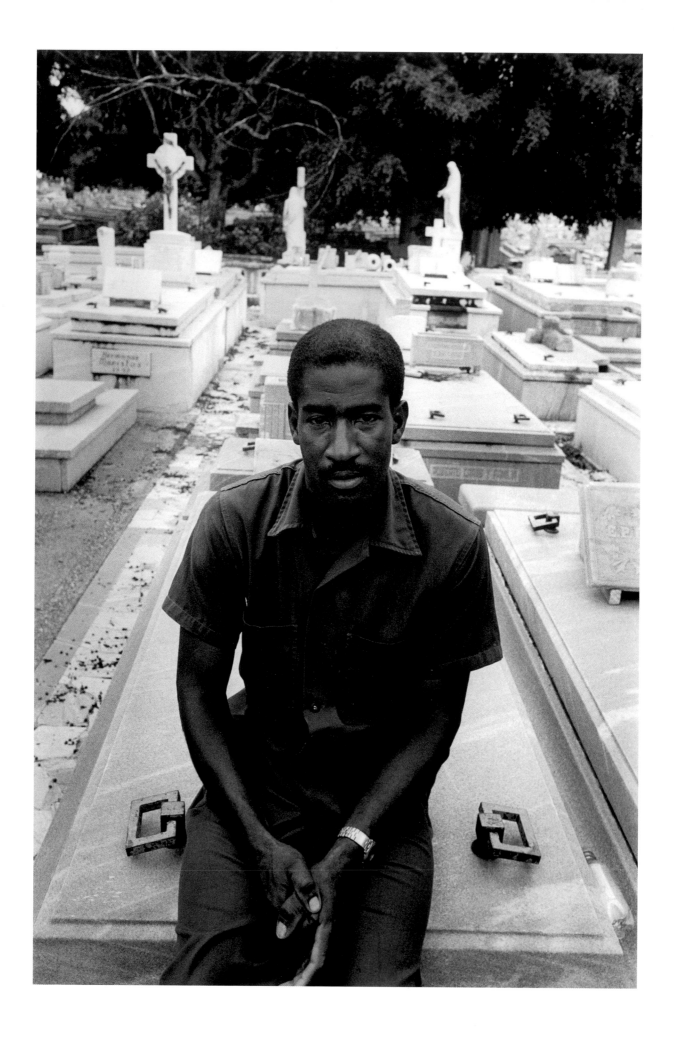

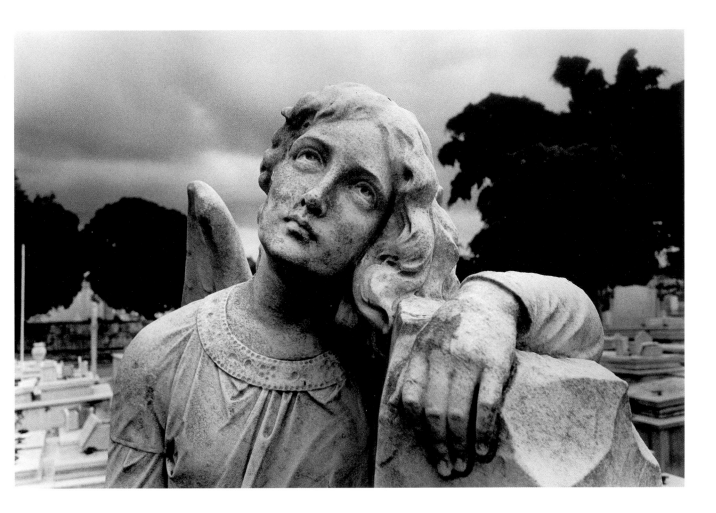

Death is really the most natural thing, even though there are people who think that it's scary. Because when you die you cease to exist.

At the point of death nothing that you have done in life will be thrown in your face. Because after you're dead it doesn't matter if they throw you over here or over there. Especially if you don't have any relatives. Why, who's going to bother about you?

And we have to take action because we can't complain. And I go out every day fighting, struggling still.

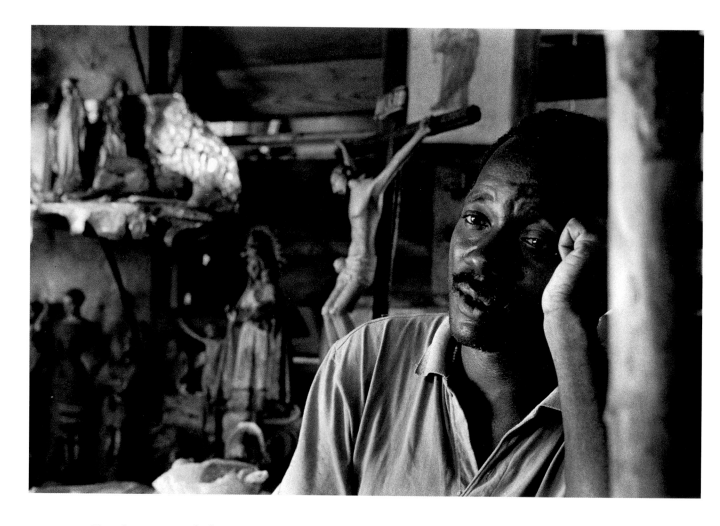

Here in Havana it's the Virgin of the Seas, the African Virgin. In Oriente there's the Copper Virgin of Charity, the Haitian Queen, the Gypsy. She protects the poor, children, widows, married couples. She performs miracles and that's why she's called the Gypsy. The Virgin of Regla gives everything to charity, she comes from faith, from copper, from charity. One looks for charity where one should be looking for development, luck, health, but one has to implore the great divine power. Here we worship her as a doll dressed in yellow, full of flowers. The Virgin of Regla dresses as an African, because she's the African mother, the owner of every living thing.

There's also the Haitian queen. That's why we, as her worshippers, we like all the yellow fruits—mangos, pineapples, oranges, and we like to play cards, predict the future, protect people who are help-less. She is not a beggar, she is a savior. We throw perfume on her, and we free a pigeon and according to how the pigeon flies it gives you freedom. That's the way you breathe freedom and the holy spirit. Always, wherever we are, we light many candles for her.

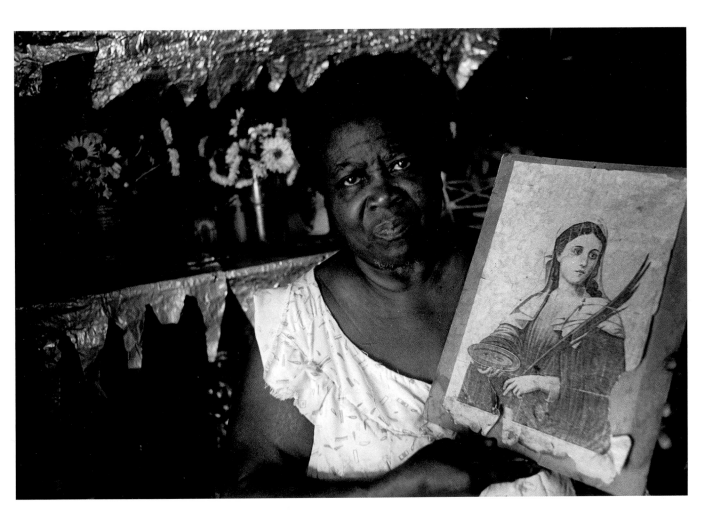

This is a house here, but it's also a house that represents Africa. I am the *madrina* (godmother) of Raul, his mother, his sisters, and he says that I am a wise woman. Raul helps me a lot. Yesterday, during our ceremony, he supported me, he treated me with respect, with tenderness when he held me in his arms. It's as if my house were their house. I share everything. What I do is a little like being a psychologist.

I don't have any blood children. I miscarried at six months. I want to say that every time someone does something pleasant for me it's as if they were my children. In our religion we call them "children of stone," which is like they are your own. You sacrifice a lot for them, you suffer for them, but it's not exactly the same as having your own children. Of course sometimes it bothers me because I feel empty not having my own children born from the womb. But what I didn't have in the past, I have now, thanks to my religion—a big family.

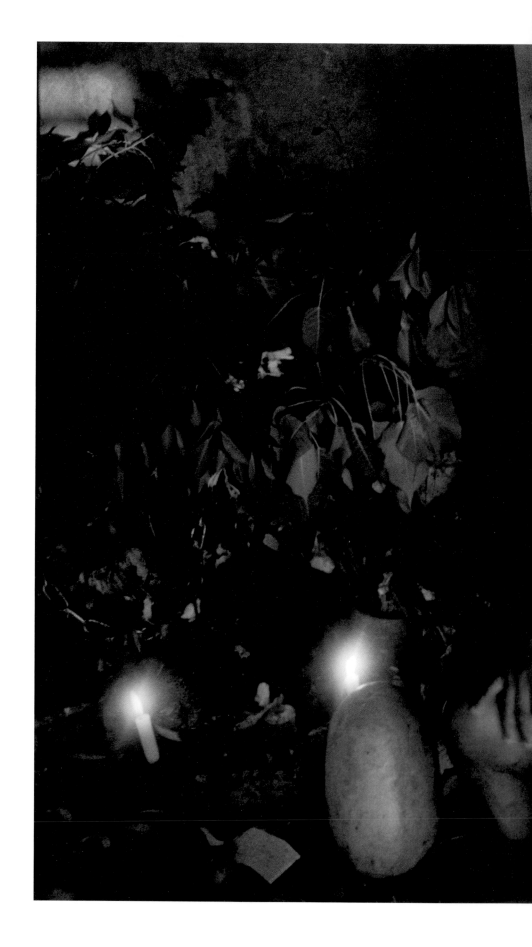

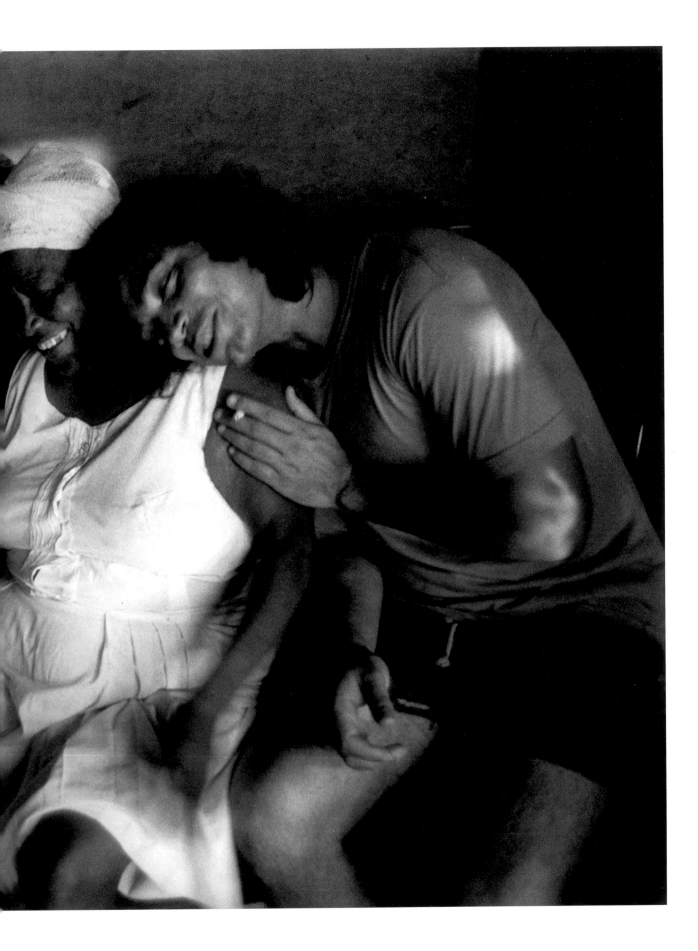

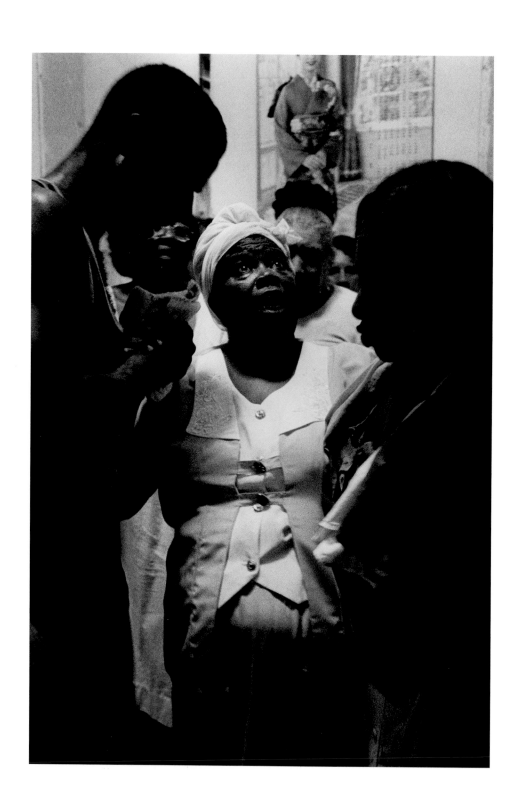

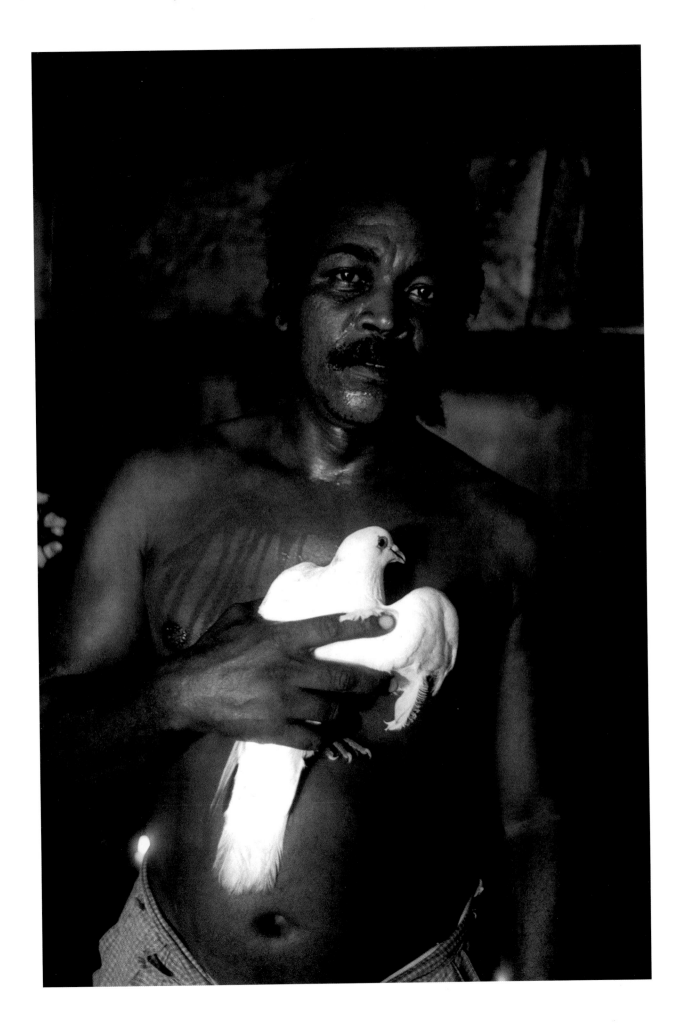

Religion gives the good with the bad, it helps you, it brings you up and everything. A lot of people come to me, of many colors, from many places. We all get together. And we all become one. There is no difference of color; we are of one heart. Here we are all one. All these people that you see here, it's as if they sprang from my flesh. All of those that come from afar, we all share, they bring things, they leave, they come back. Fate, luck. Here we are all one light, it's a community. Here we celebrate people, one another. There's a lot of respect, a lot of love. A lot of consideration. It's also a way to alleviate tension, to bring spiritual messages, and to give relief to people. Relief.

Before you couldn't have these ceremonies in Cuba. First came the Party. But the Party had to move aside and make way for religion. Religion is stronger. Religion is stronger than politics. That's the way it is.

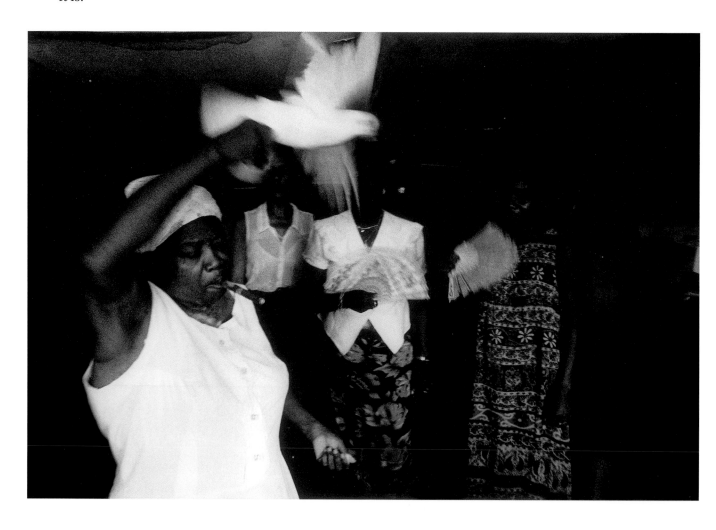

When we have a ceremony it's like part of the church but in an African way. We work for the church, we work in an African way, and we work for the saints. You can see a lot of Africa in all this. I would love to go to Africa but I haven't been able to yet. I would like to go to Africa, to Haiti. The transmission of voices comes from the African way. People speak that way because they change. The life of a saint is like leading a normal life. Like let's say you are from one country and I'm from another and when we die we have contact with people, we come speaking our language and yours.

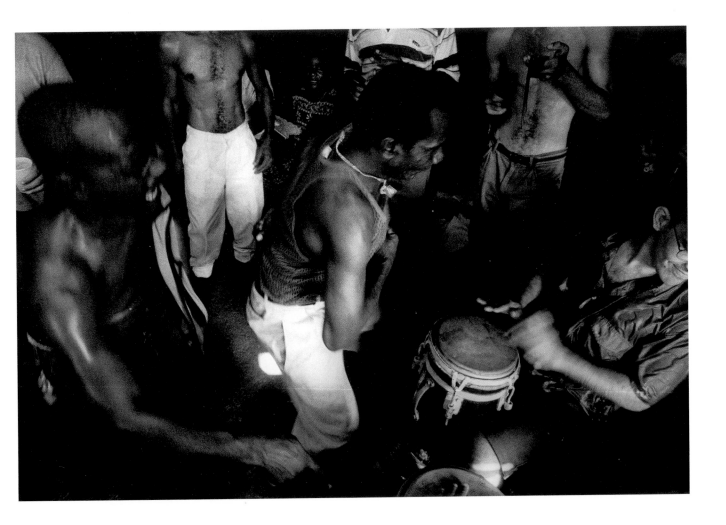

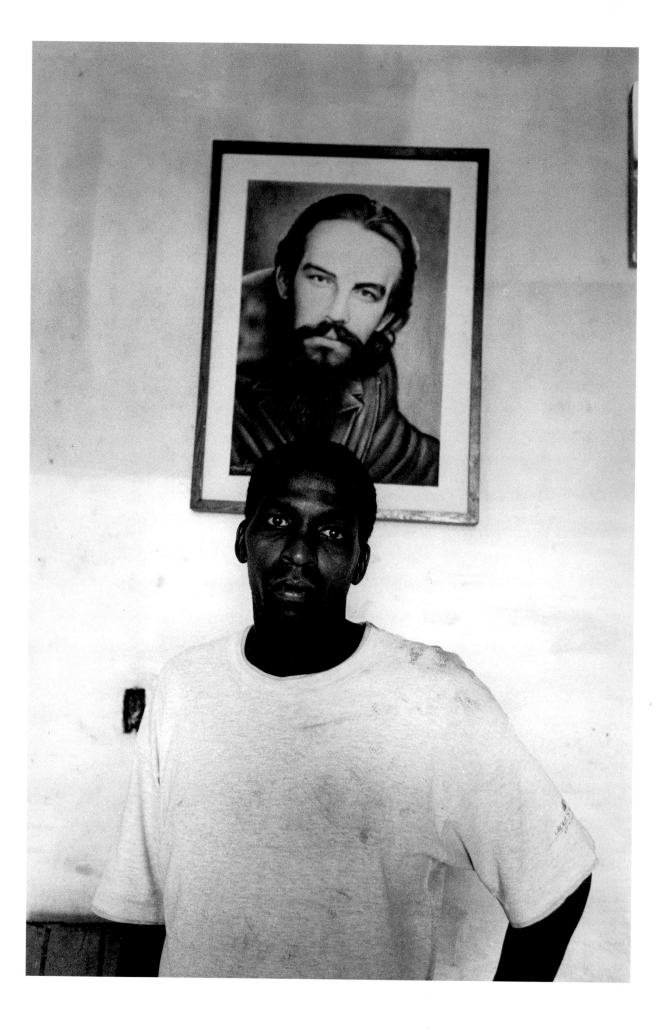

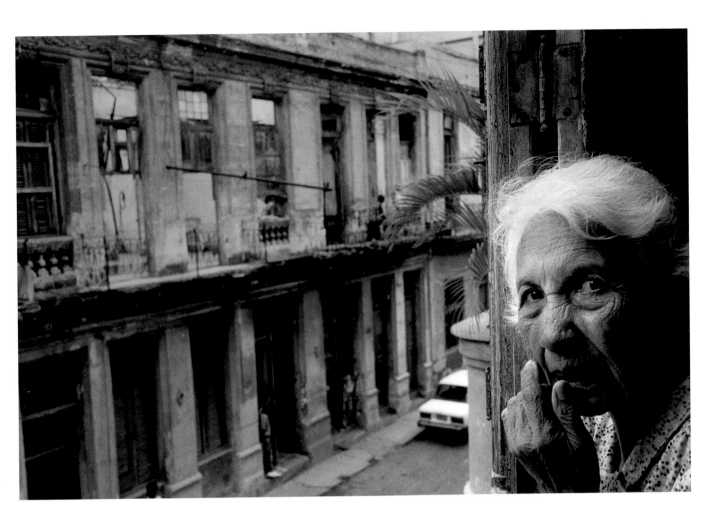

I have been living in this house for thirty-seven years, but I wouldn't be able to tell you the date of its construction because I wasn't born yet. This house belonged to the parents of my parents, or my great-great-grandparents. All my ancestors have lived here. Now part of my family lives in the United States. Because my grandmother died and some of my family emigrated. We're getting back together slowly but surely. So, the only people that live here now are my sister and I.

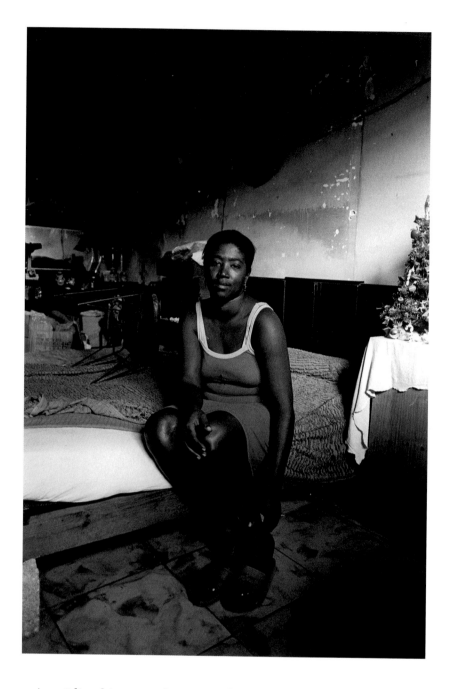

After my marriage I lived in many houses and I worked hard. I'm thirty-six years old. Now I would like to live what I have left of life in this house. In any case, at least it has certain comforts. Because I have already been through a lot, but you get used to everything. But I mean, what about clothes, the necessities for the bathroom, the cold, the heat? Comfortable I am not.

There's only one single window. It's difficult to sleep and the humidity's horrendous.

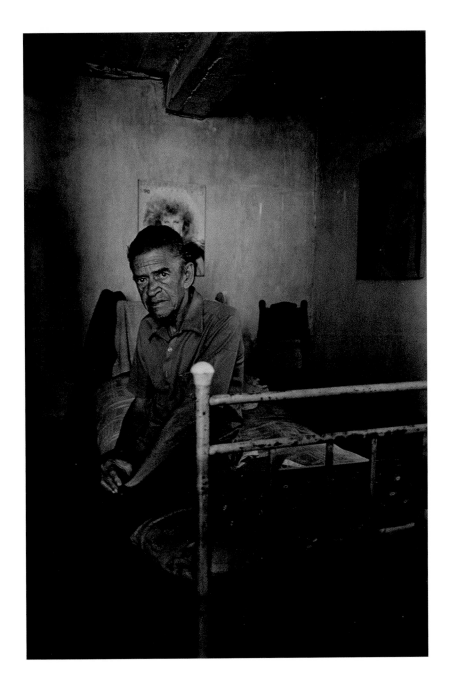

The problem here is you can't open the window so that fresh air can come in. And there's very little light. To see the sky you've got to go outside because you can't see it from inside. You always have to turn on lights here. For example, if it's cloudy, if it's going to rain, it gets really dark. You have to turn on the light, you know?

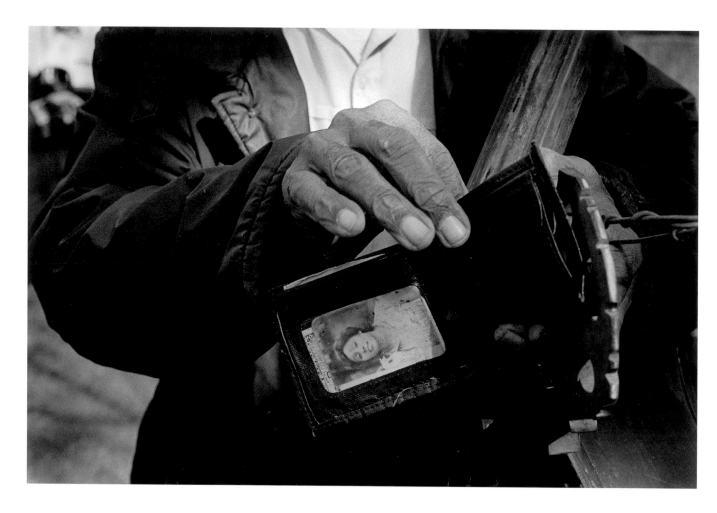

This love story? It's a story of passion. I can teach you a lesson from it. We were going out as they say, right? She was very young. And this is pretty funny. I was young, too, and good-looking, you know, and ever since she was a little girl she had been sweet on me. But the family, her mother, didn't want us seeing one another even though her mother and I got along well and we were born and raised in the same small town. I was always hanging around their house. I lived there almost since I was a small boy and I was growing and she was really good-looking—beautiful hair, long, down to her waist, long and beautiful. So we fell in love. But you see she was younger than I was and her mother still didn't like it. She didn't like that I had a lot of girlfriends. Hey, I was really young. So I had a few, so what? So the mother said no, and her daughter insisted and wouldn't leave me alone. They hit her. Yeah, I mean they hit her. She was only twelve, thirteen, really young. They didn't want her to be with me, but she insisted and I, well, I accepted her. But I talked with her mother, tried to reason with her, but she was afraid I might commit some illegal act with her daughter. I got a house and that settled things.

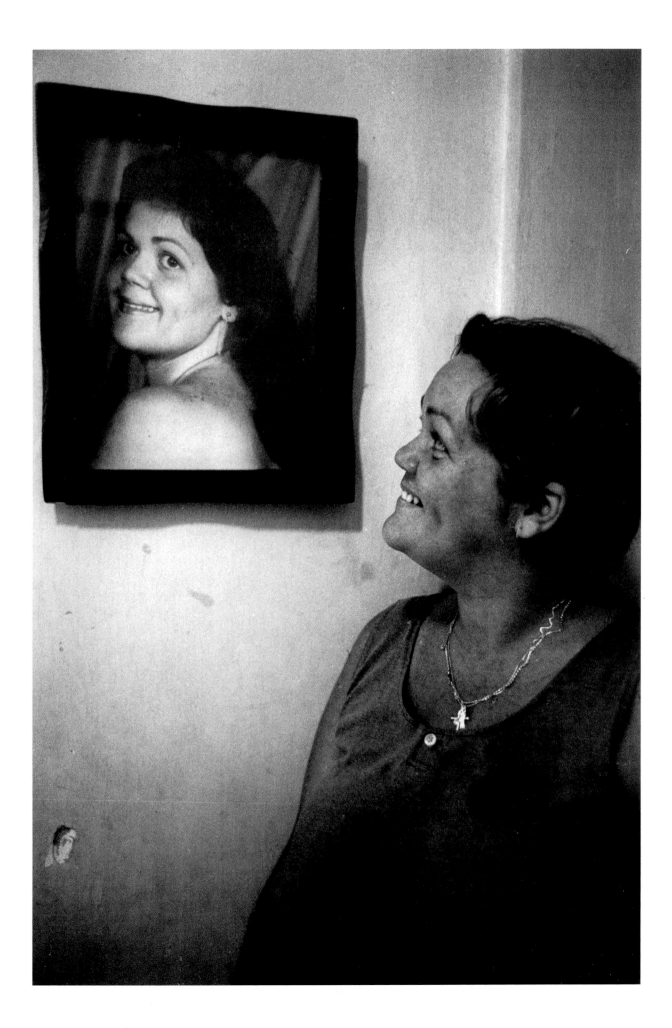

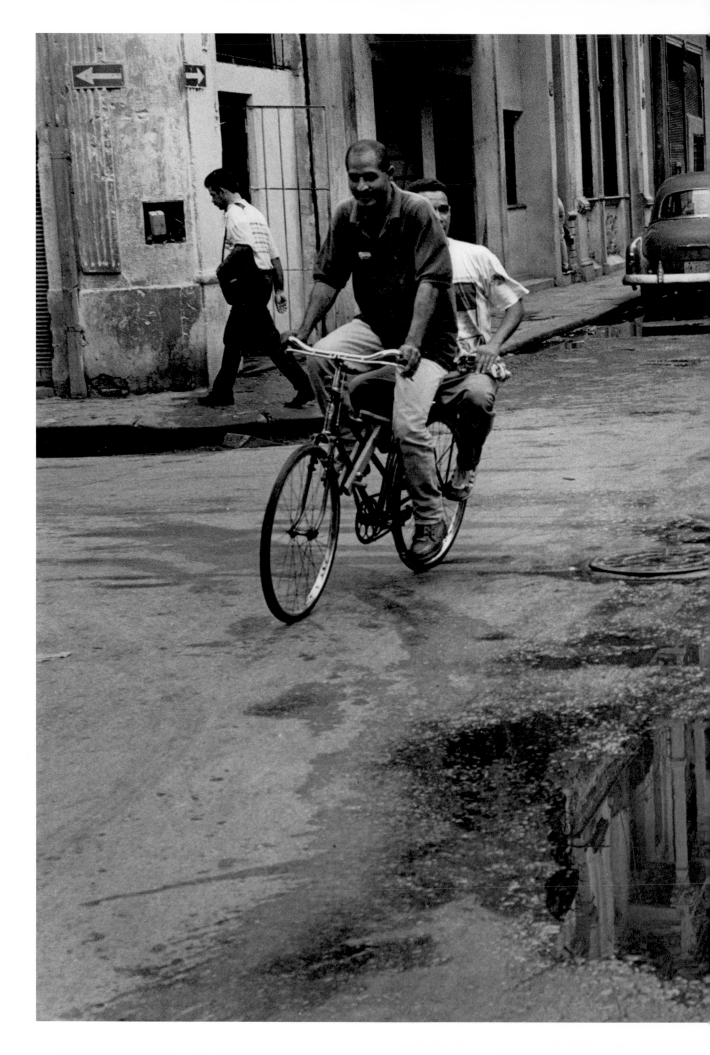

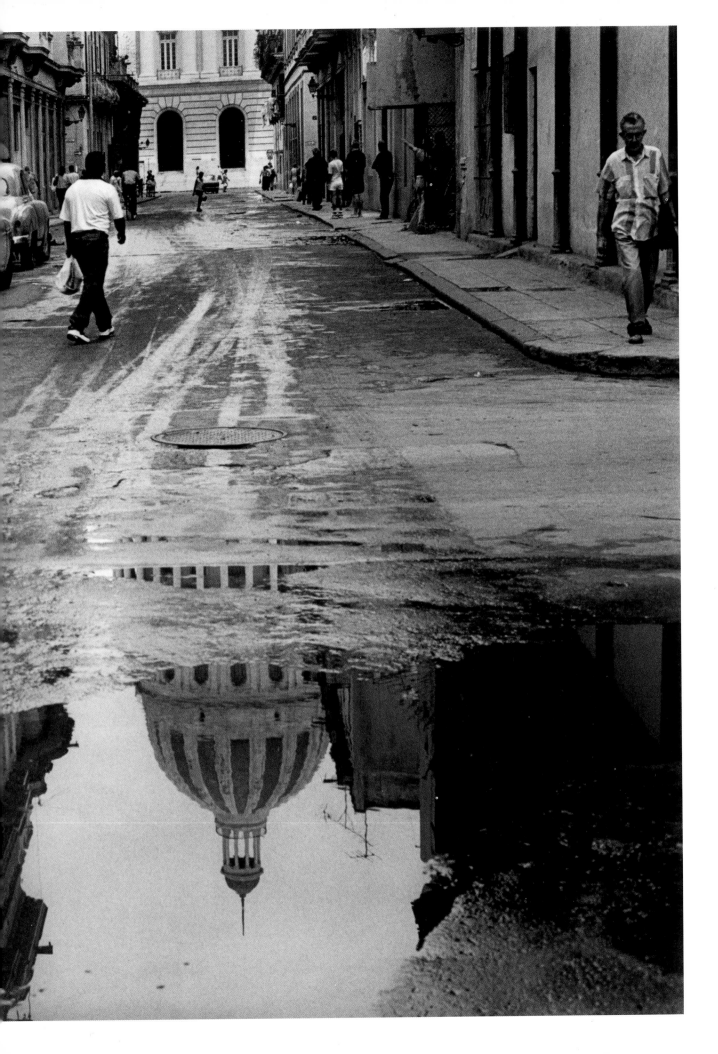

My house is pretty small. But I live modestly, the way I should live, the way everyone should live. It's nice, my little house, my children, my job. I don't want much else. I've done the things I've had to do now, so what more do I need?

We're ten people living in this house. There are three *barbacoas* (lofts) up here and two below. And one bathroom. Everybody's fine. The usual problems, like families everywhere in the world, but everything's okay. Up until now there's no problem with food, like for example if I'm going to cook something and someone says no, that's no good. Here we cook the same thing for everyone, no matter what. It's like a buffet. Everyone eats at the same time, too. This is the bottom line for family life—to eat together. To share mutually and not have any family tension. Everyone eats at the same time and whatever there is. Everyone shares no matter what.

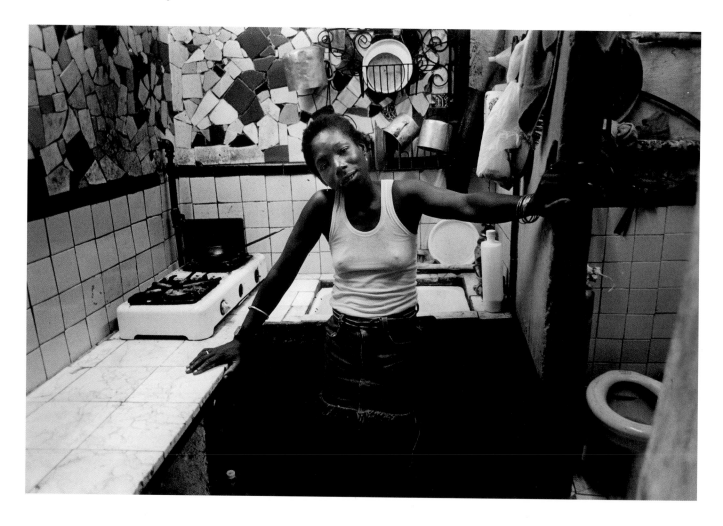

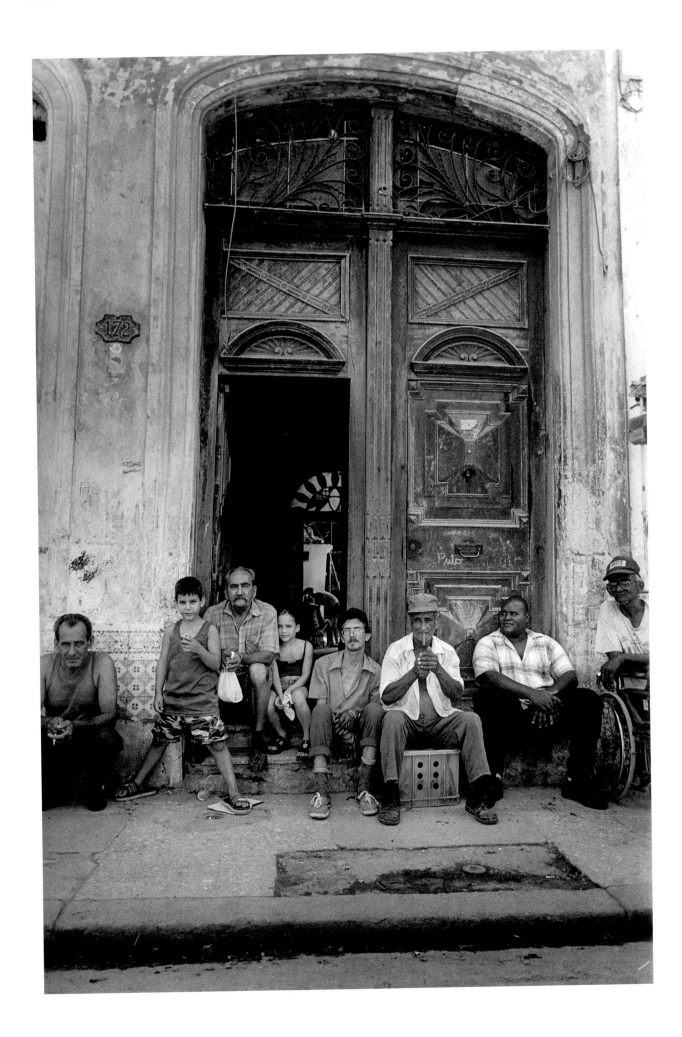

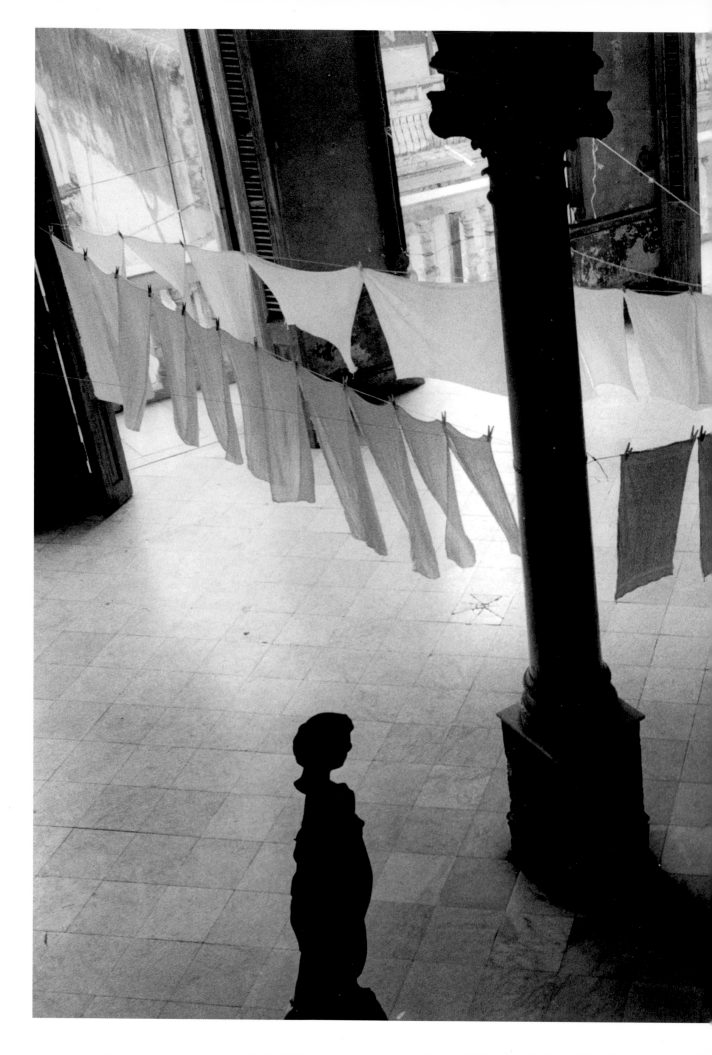

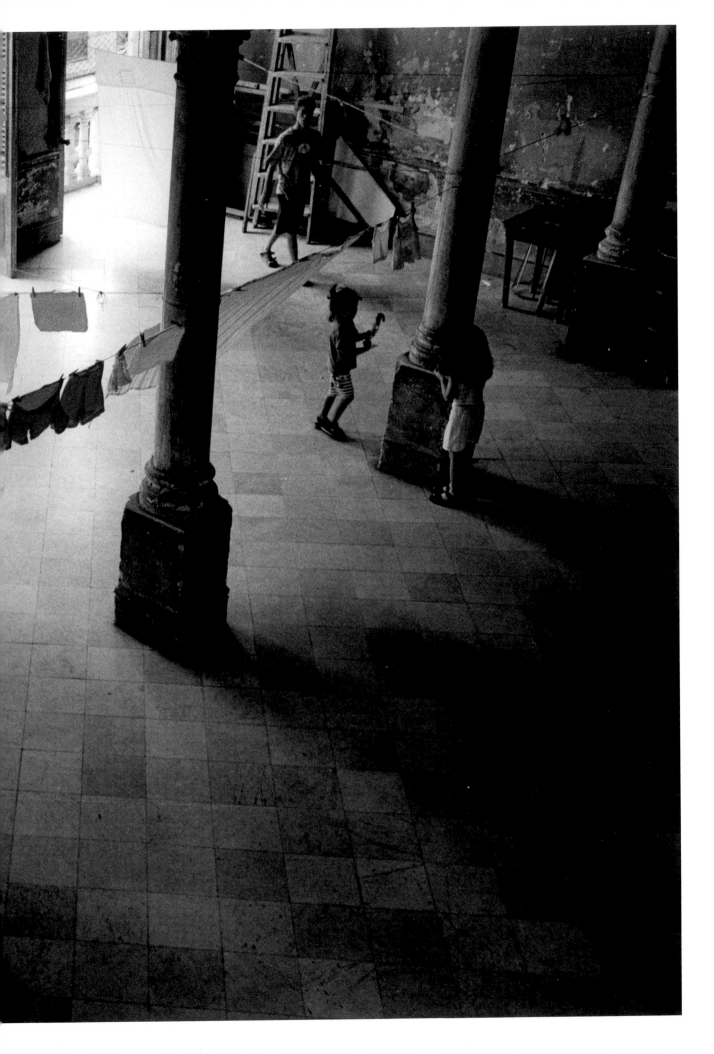

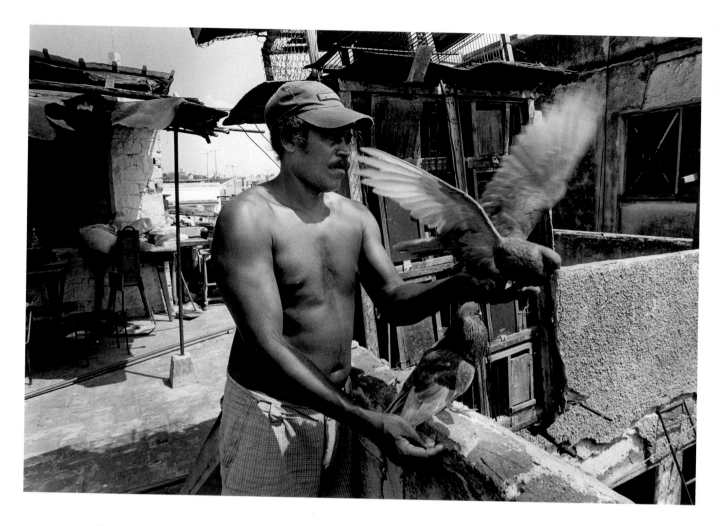

A lot of people here in Havana breed pigeons. The love that exists between pigeons is the deepest of any kind of love. It's for their whole life. It's the most faithful love there is. And the male will kill another pigeon that comes between him and his mate. Everyone in life does what they can. And if one pigeon dies by accident, then the other can fall in love again. They always return to the same place, the same home, even if you take them forty, fifty kilometers away. The government wants to take away this private business from us. I won't give mine up. They're mine. Everybody who breeds pigeons has happiness. At least that's what they give to me.

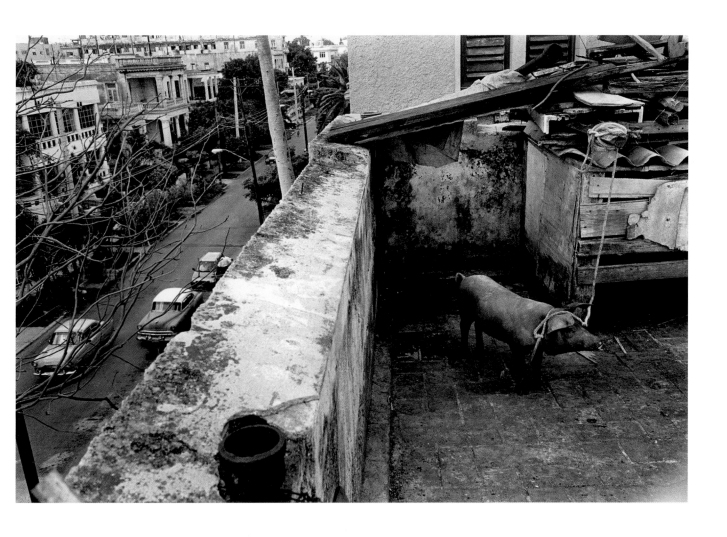

Look, when we came here to Havana in 1952 this building was a thing of beauty. Very nice, very nice, very nice. They didn't rent to children or anything, so it wouldn't get destroyed. No dogs, nothing, to preserve it. But as time passed, and the system changed, it's another story. Because now there's no manager who takes care of things. We don't pay any rent here.

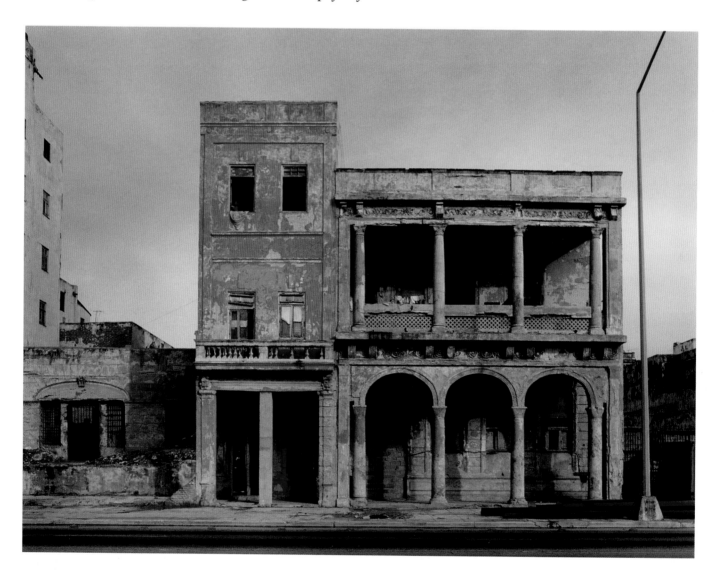

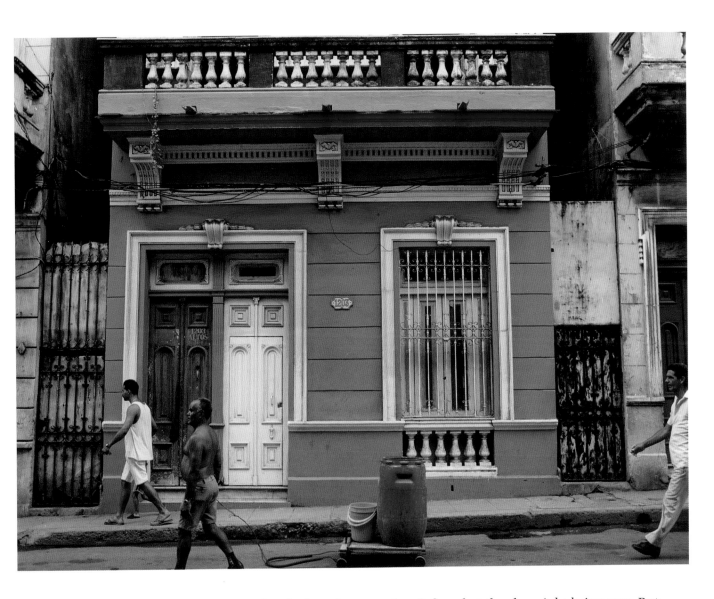

There's an expression "Sit under the laurel trees and wait for what the sky might bring you. But don't expect anything. It won't come." I bought only this chair. The rest of what you see is what I made right here in my kitchen. This plank of wood I made into the kitchen table. And also up there, the *barbacoa*, I made it too. Because, listen, there was a time when things were hard, though now it's getting better. But it was very bad. First I went to the market to buy a sack of cement and I brought it back here to make what you see. The stairs also. And then they say that there are no problems here. Right. There certainly are problems here. And they don't come from the sky. But here in my house a lot of air comes in. It's pleasant.

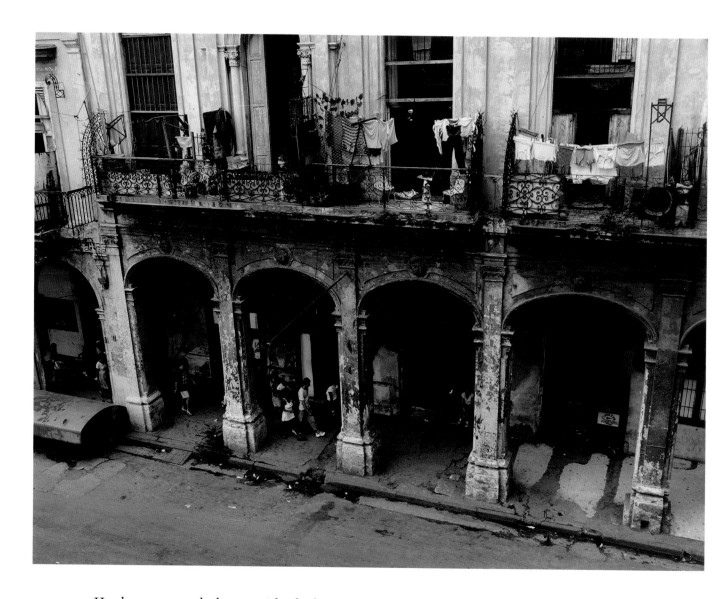

He always wanted a house with a little garden where he could plant flowers to pass the time and relax. I too would have liked a garden to plant fruit and those kinds of things. You pass the time that way, but well, we haven't had that kind of luck up to now, to have the house that we wished for. They give away houses. There are some houses, yes, with two floors, three floors, but our inner courtyard is only a place to get water, hang the wash. But there are some houses with really big courtyards. And they have the courtyard in the back where you can plant and everything. But I haven't had that sort of luck, you know?

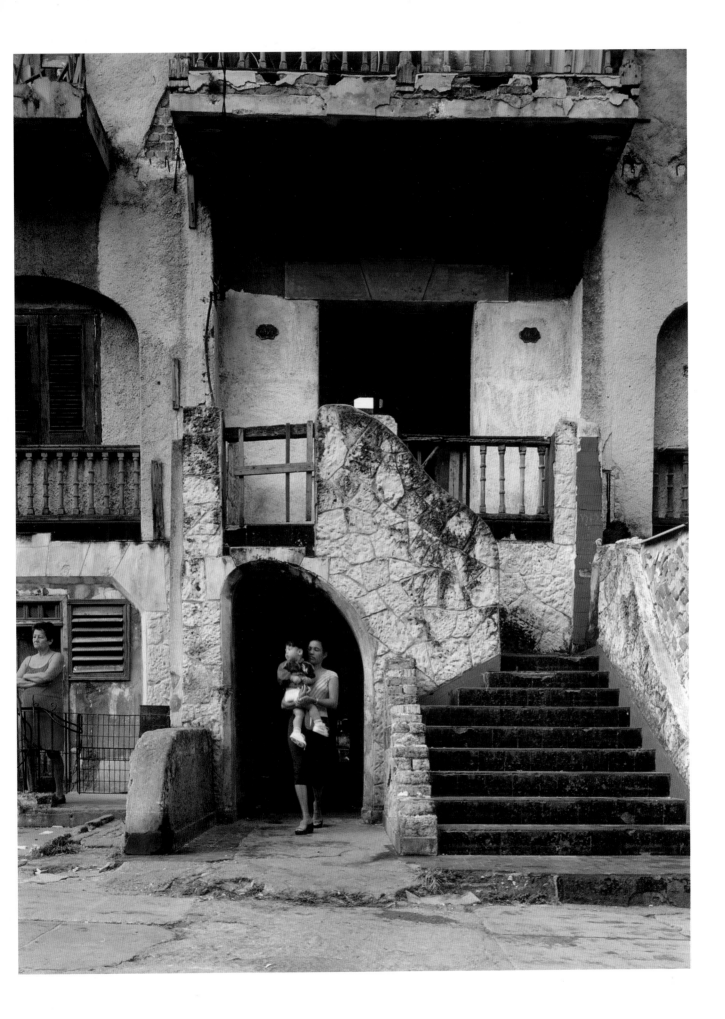

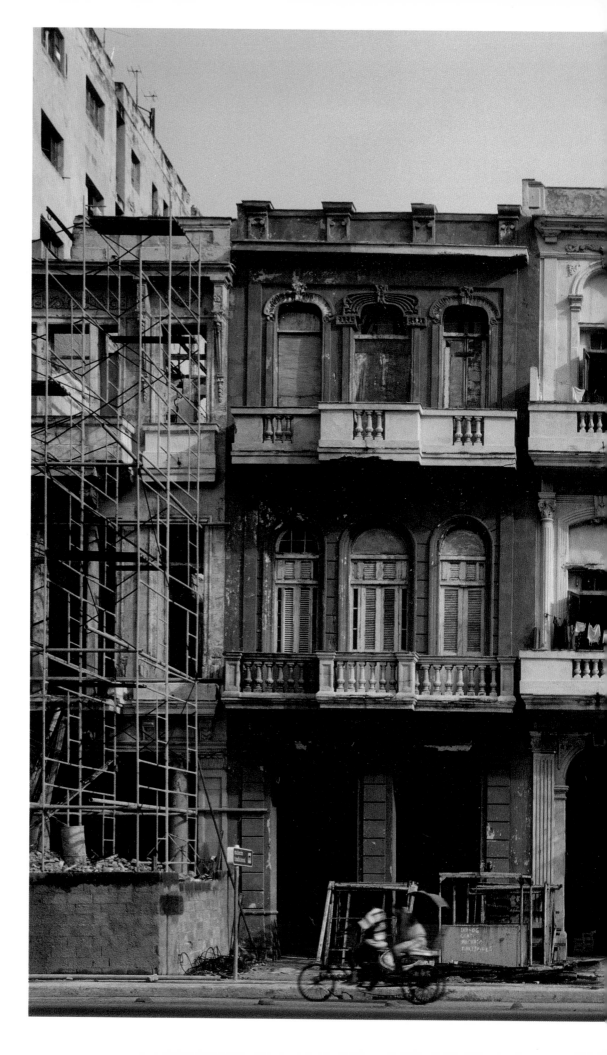

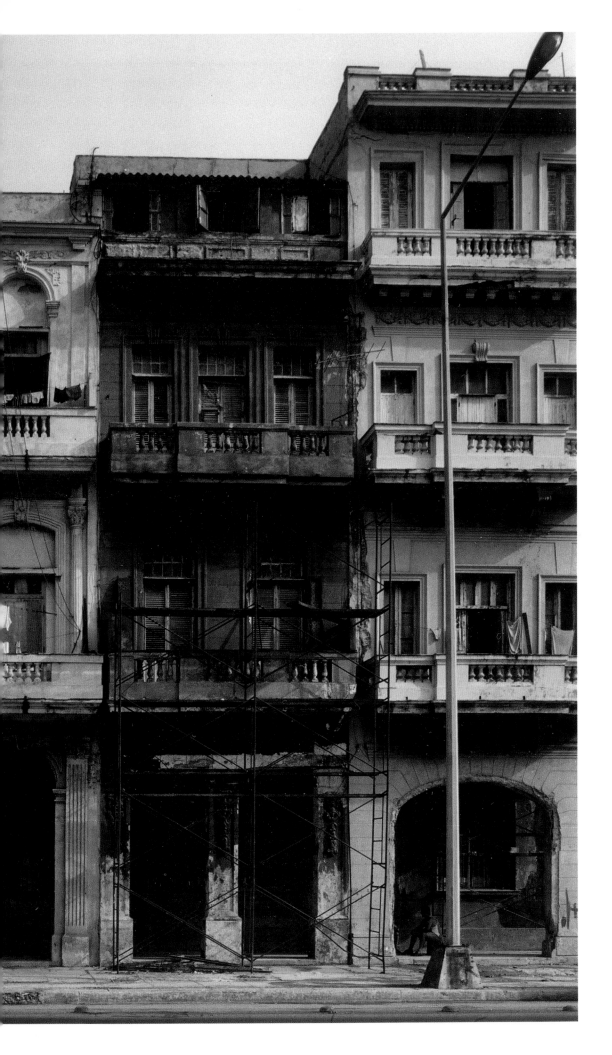

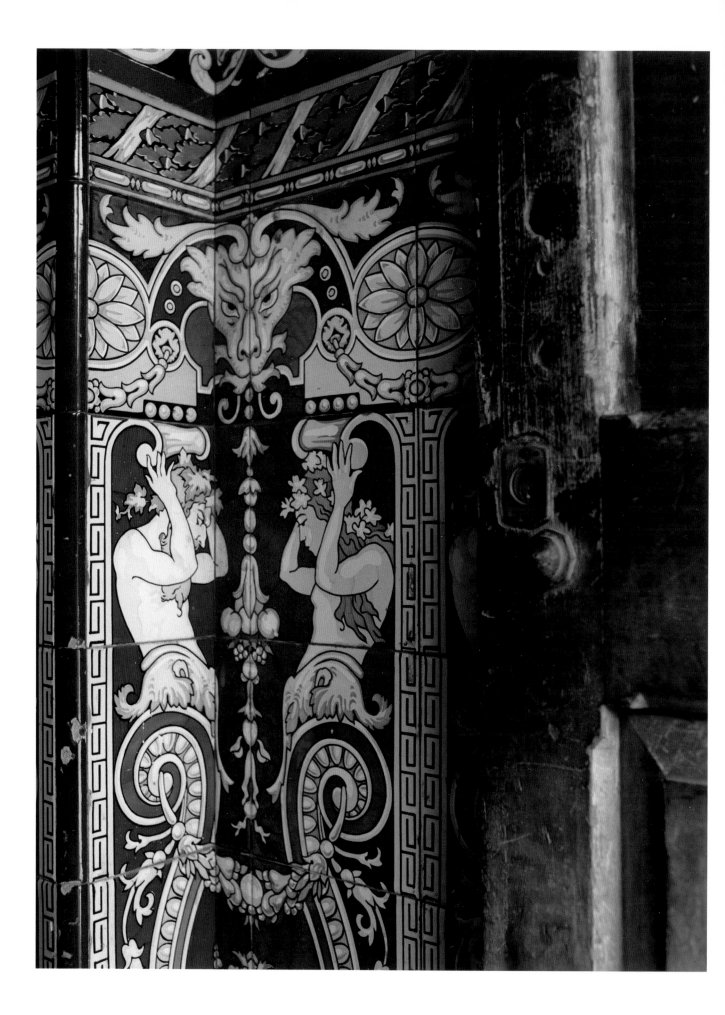

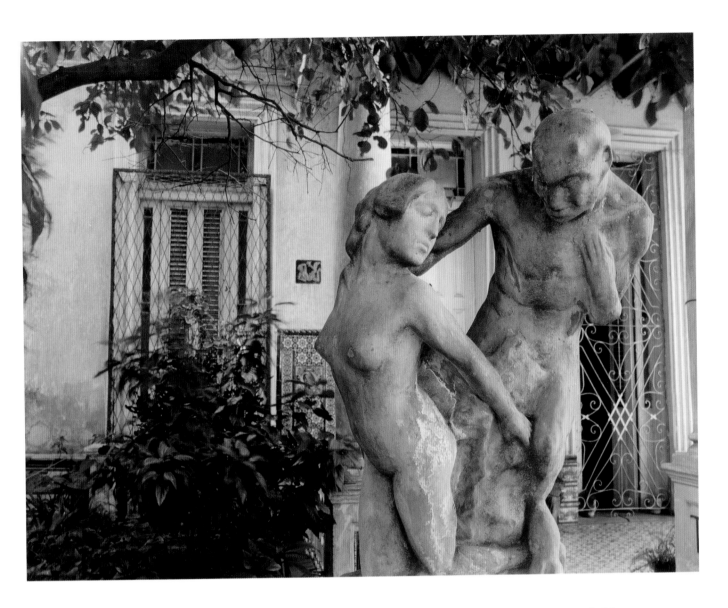

The house, the home is something very simple, a composition that must be surrounded by everything from nature, from a simple nature where we are born, we live, and that is pleasing to us, that makes us tremble, that makes us feel, that makes us dream, and value life. So you see, nature for me is life, the nest from which everything grows.

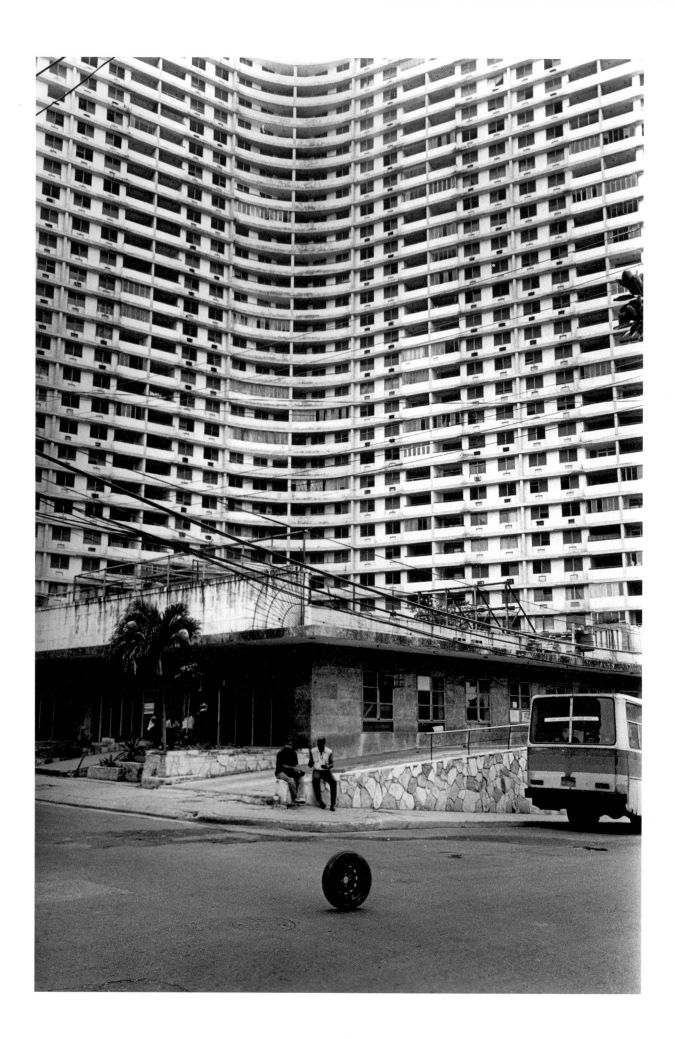

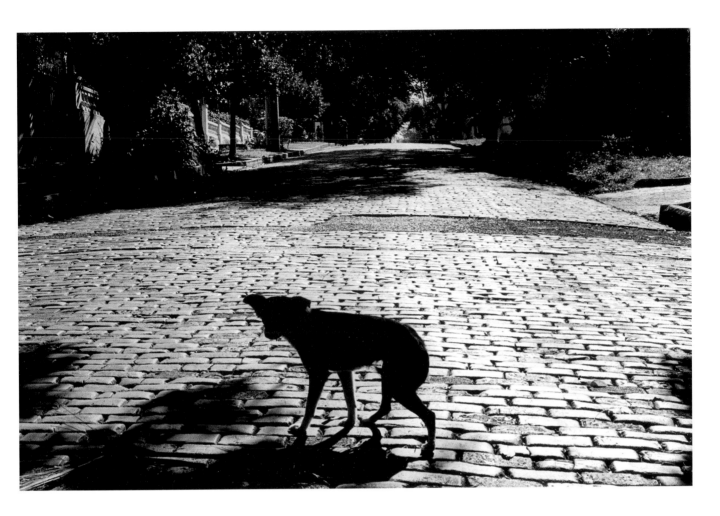

It's as if he were a child, my dog. For him the house is the place where he feels comfortable, where he has company. And the proof of this is that at times I used to have to go out, and he got very sad. So, I'm like a home for him. Yes, like a home. In the daytime I get in my favorite corner and he lies down beside me in the bed. I feel good there beside the window every day, every day. And if I go away he gets sad. If I'm in the kitchen he's always beside me. He's very keen-sighted and he's always beside me. I'm in no danger when he's beside me. He has his own bed, but when I'm up he gets up too and keeps me company. His name is Happy.

There's a lot of pressure, and because of this you need a lot of tranquility. You've got to have initiative. And patience. We have a problem of paternalism here. Everyone is waiting for a house to fall from the sky, a house that someone's going to give them. Because there are a lot of benefits, a lot of things that we can have in this situation we find ourselves, like social and economic things. But you've got to make an effort. The easiest thing to do is wait. Wait for something to happen—like another house in a different neighborhood in Havana. And then there are people who just don't care.

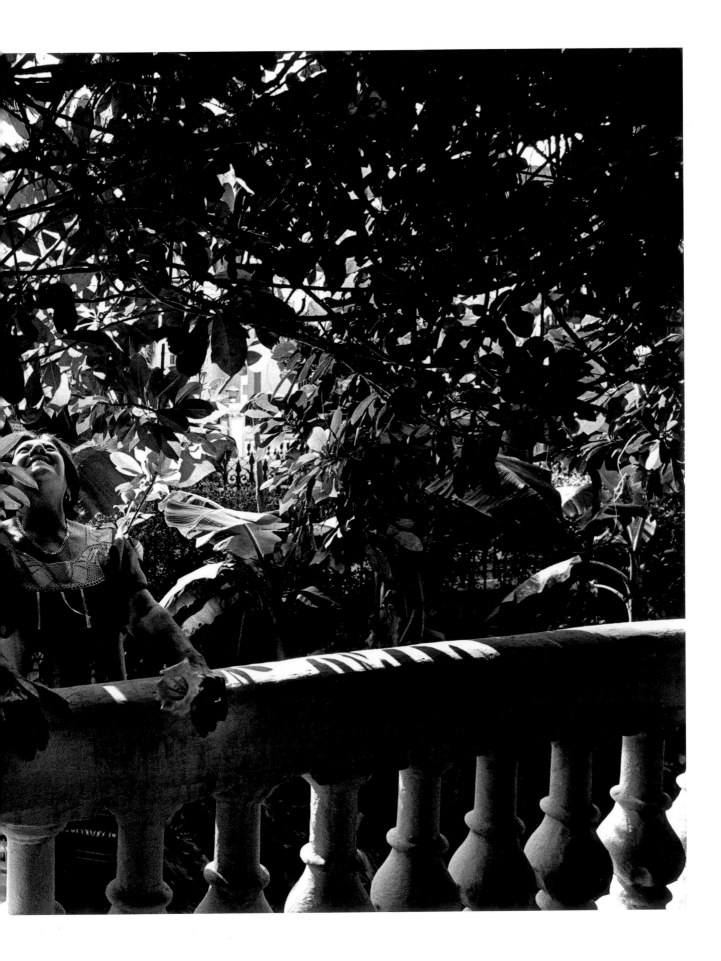

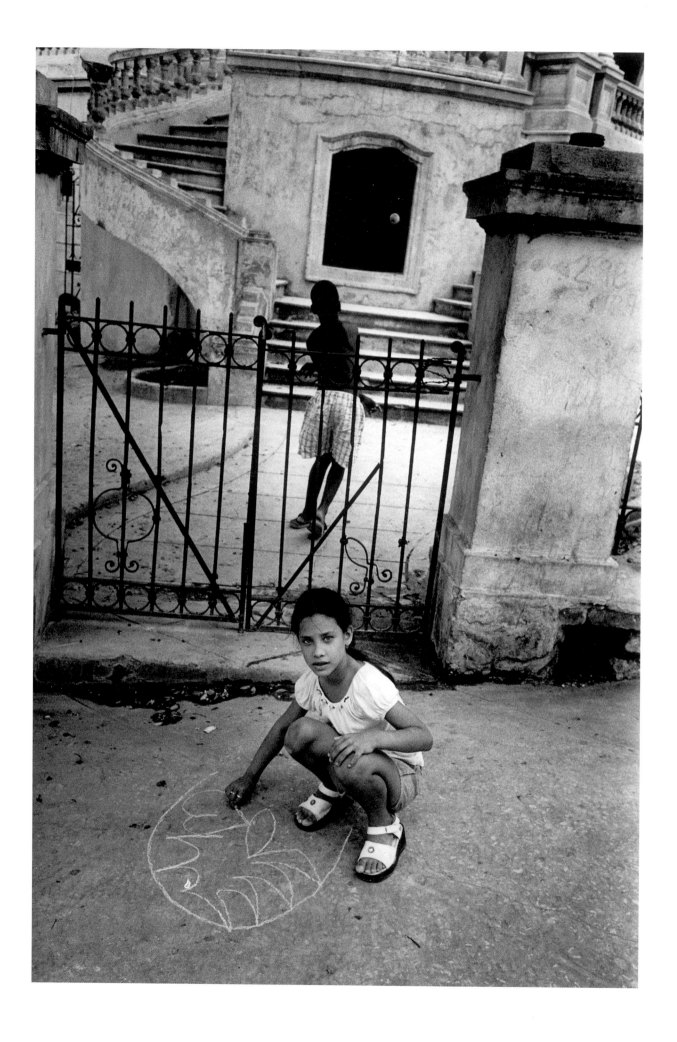

WAITING FOR A TRAIN

ALEX FLEITES

We have spent our lives waiting for a train
Each morning we went to the station
with flags and flowers and there we waited
until the night gave permission
that the palm trees and the clouds
become the same sea of darkness

We are waiting for a train, our parents told us
We are waiting for a train, we replied to our children
when they looked at us with amazement or hatred
as we jumped through the years between the rails, put on the music,
adorned the platform with our humble plants

At first we used to receive news of its passage
through cities and towns with enigmatic names
but today there only remains the habit of spying on
the long-lost idea that our lives have reduced themselves
to waiting for a train which will take us
toward unknown destinations
where tired women and taciturn men
and children with eyes slanted by sleep
are waiting for a train to go to another station
where others are waiting to travel
with faces and gestures identical to ours.

LIST OF PHOTOGRAPHS

ABOUT THE PHOTOGRAPHER

Vincenzo Pietropaolo was born in Maierato, Italy, and grew up in Toronto. His award-winning work has been exhibited widely across Canada, and also in the United States, Europe, and the Caribbean, including Cuba. His work has also been published extensively. His latest book was *Canadians at Work,* which was published in 2000.

ABOUT THE AUTHOR

In pursuit of stories, Cecelia Lawless has traveled through Latin America and Spain. After completing comparative literature studies at the University of Toronto and Cornell University, she obtained a Fulbright to teach in Venezuela. She now teaches Latin American literature and film at Cornell. She makes her home in Ithaca with her family.